Asuka Buddhist Art:
Horyu-ji

Volume 4

THE HEIBONSHA SURVEY OF JAPANESE ART

For a list of the entire series see end of book

Asuka Buddhist Art: Horyu-ji

by SEIICHI MIZUNO

translated by Richard L. Gage

New York · WEATHERHILL / HEIBONSHA · Tokyo

This book was originally published in Japanese by Heibon-
sha under the title *Horyu-ji* in the Nihon no Bijutsu series.

A full glossary-index covering the entire series will be pub-
lished when the series is complete.

First English Edition, 1974

*Jointly published by John Weatherhill, Inc., 149 Madison Avenue, New York,
New York 10016, with editorial offices at 7-6-13 Roppongi, Minato-ku, Tokyo
106, and Heibonsha, Tokyo. Copyright © 1965, 1974, by Heibonsha; all rights
reserved. Printed in Japan.*

LCC Card No. 73-88473 ISBN 0-8348-1020-4

Contents

Asuka Buddhist Art:
Horyu-ji

CHAPTER ONE

—◆—

The Beginnings of Buddhist Art in Japan

THE HORYU-JI The monastery-temple Horyu-ji stands in a quiet rural neighborhood (Fig. 1) in the western part of the Yamato Plain, some distance from Nara, the eighth-century capital of Japan. The entire Yamato district (Fig. 2) is rich in historical monuments of the greatest importance, and the Horyu-ji is one of the most significant. It was founded in the early seventh century by Crown Prince Shotoku (Shotoku Taishi; 574–622), who was regent to Empress Suiko and one of the most remarkable men in Japanese history.

In order to help the reader understand the general layout of the Horyu-ji, I shall open my discussion by briefly describing the major temple buildings. Reference to the aerial photograph (Fig. 3) and to the foldout plan facing page 24 will be of assistance in following my description.

Though the Horyu-ji is not vast, as were some of the temples of the Nara period (646–794) later, its two major precincts nonetheless occupy plots of considerable size. The visitor enters the well-kept, tranquil grounds through the South Main Gate (Nandaimon). After walking along a fairly short path lined with subtemples, he reaches the West Precinct, within which the Inner Gate (Chumon; Figs. 105, 106) leads into the main compound of the temple. Surrounded by veranda corridors (Fig. 107), in a yard spread with white gravel, stand the main hall of the temple, called the Golden Hall (Kondo), and the five-story Pagoda (Fig. 16). These two stand on either side of the north-south axis of the compound. Behind them, and set into the veranda corridors, is the Lecture Hall (Daikodo; literally, "Great Lecture Hall"). The Sutra Repository and Belfry are now integral parts of the corridors on the left and right, though in the original temple plan both these buildings and the Lecture Hall as well were free-standing and outside the main compound. This older layout may be seen in the foldout plan facing page 24, where the older, no longer extant, structures are shown in red and the buildings as they exist now are shown in black. This main compound includes the oldest examples of wooden architecture in the world: the Golden Hall, the Pagoda, and parts of the corridors. To the west of the main compound are an octagonal building known as the West Round Hall (Saiendo) and monks' quarters with a chapel called Sangyoin. Both are rebuildings of later times. Directly east of the main compound are more monks' quarters with a chapel called Shoryoin. These too are of later date, as is the Refectory (Jikido), slightly to the east of them.

A broad avenue leads past the West Precinct, its two ponds, and other outer buildings to the East

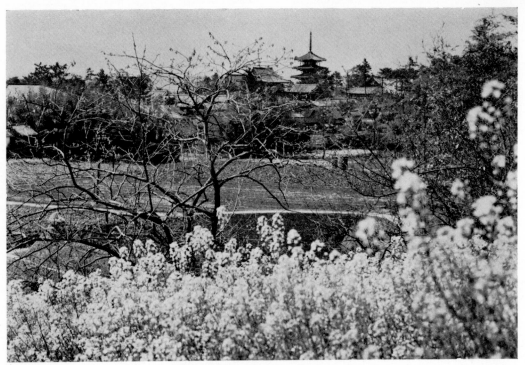

1. *Rural setting of the Horyu-ji; the Golden Hall and Pagoda can be seen in the background.*

Main Gate (Todaimon). Beyond this gate, the avenue continues to the East Precinct, the main buildings of which are the octagonal hall called Yumedono (Dream Hall; Figs. 152, 153) and a lecture hall known as Dempodo (Figs. 154, 155). Northeast of the Yumedono compound is the Chugu-ji, a nunnery possessing a movingly beautiful statue of Miroku Bosatsu (the Bodhisattva Maitreya; Figs. 59, 77). In addition to these old buildings, there is the modern concrete Treasure Museum located between the East and West precincts and filled with an incomparable collection of art works from the sixth and seventh centuries.

It is primarily these art treasures and others housed in the main temple buildings, as well as the older buildings themselves, that I shall be dealing with here, for this remarkable group of relics of the past constitutes the great significance of the temple. Indeed, the Horyu-ji is so intimately connected with the development of Japanese Buddhist art that a discussion of one presupposes some knowledge of the other. The influence of the temple and its treasures may be traced through many centuries, but limitations of space prevent me from taking this discussion any further than the late Nara period. Consequently, I shall first discuss the introduction of Buddhism into Japan and the earliest works of Japanese Buddhist art. I shall then move to masterpieces of the Asuka period (552–646) and the Hakuho, or early Nara, period (646–710). Finally, I shall mention a few works from the Tempyo, or late Nara, period (710–94). (The boundary between the Hakuho and Tempyo periods is usually given as 710, but in Chapter Five

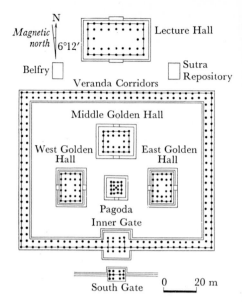

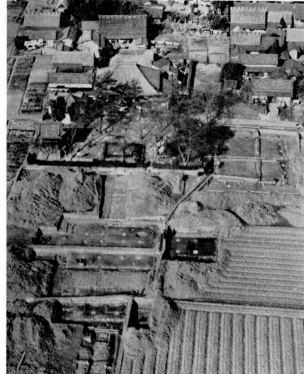

4. Above: plan of Hoko-ji; right: aerial view of Hoko-ji foundations (596). Ango-in (Asuka-dera), Nara.

doubtful that it could have exerted as great an influence as this statement suggests. Shiba Tatto built a pagoda where he enshrined Buddhist relics, but this pagoda, too, did not approach a full-scale temple in size or importance.

By an odd coincidence, at about the time when Umako and his associates were engaging in these Buddhist activities, a plague broke out in Japan. Conservative forces under the leadership of the Mononobe—especially Mononobe no Moriya—and of the Nakatomi were eager to read into the disaster the wrath of Shinto deities offended by the newfangled foreign religion. Anxious to eradicate the cause of the grief, they hastened to burn Umako's chapel and Shiba Tatto's pagoda to the ground. For good measure, they hurled the Buddhist statue enshrined in the chapel into a canal

and had the young nuns publicly whipped. Unfortunately for the conservatives, however, the outcome of their vigorous efforts was less salutary than they hoped—Mononobe no Moriya and the emperor caught the plague. Seizing upon this opportunity, Soga no Umako obtained permission from the ailing Emperor Bidatsu to pray to Buddha for relief from the devastating plague. Thus, in a roundabout way, the conservative attempt to use the plague as a means of abolishing Buddhism succeeded in providing the religion with a kind of recognition.

Still, Bidatsu never took a truly firm stand on the issue of Buddhism. His successor Yomei (r. 585–87), however, did not equivocate. He is said to have reverenced the Shinto gods, as was appropriate to a ruler supposedly descended from one of these

deities, but he was definitely on the side of the Buddhists. Nevertheless, in spite of his pro-Buddhist leanings, the emperor was unable to put a stop to the religious squabblings and strife, which grew increasingly violent until armed conflict finally flared up between the Soga and the conservatives in 587. Victory went to the Soga, who then embarked on a program of temple building.

Soga no Umako's political actions were less pious than his concern with religion might lead one to expect. To remove all opposition from his path to power, he had a young prince related to the Sogas put on the throne as Emperor Sujun (r. 587–92). Later he had Sujun assassinated and elevated his niece to the imperial dignity as Empress Suiko (r. 592–628). This was a very fortunate turn of events for the development and growth of Buddhism, for Umako appointed Prince Umayado, better known to history by his Buddhist name Shotoku, as regent to the empress. Prince Shotoku, who was possessed of extraordinary abilities, showed great zeal for Buddhist study, and it is thanks to his efforts that the Horyu-ji was established. But before moving on to that subject, I must mention some of the other major temples erected in the early years of Japanese Buddhism.

There is a tradition that the Hoko-ji and Shitenno-ji monastery-temples were built by Soga no Umako and Prince Shotoku as acts of thanksgiving for their victory over the anti-Buddhist faction, in fulfillment of vows made by them. The establishment of the Hoko-ji is well documented in the *Chronicles of Japan*, which gives dates for various stages in the temple's construction. And we know that Umako's son was put in charge of the temple, and the monks Eji and Eso, of Koguryo and Paekche, respectively, were installed there. The Shitenno-ji, however, is given very brief treatment, with no mention of Prince Shotoku. This, and the fact that Shotoku was only in his mid-teens at the time when he was supposed to have made the vow, suggest that this story is no more than legend.

The Shitenno-ji was located in the Naniwa area and dedicated to the Four Celestial Kings (Shitenno). Although the original temple was destroyed by fire, its main foundations remain intact and the temple has been reconstructed on them. It is laid out on a basic continental pattern with an inner gate, pagoda, and main hall arranged along the north-south axis. The Japanese called this layout the Kudara (the Japanese name for the kingdom of Paekche) style. The imported style was soon altered to suit Japanese needs and in later years was abandoned altogether.

The Hoko-ji was built on a site that is now in the village of Asuka, Nara Prefecture. The location gave the temple its alternative name of Asuka-dera (Asuka Temple), and of course, the Asuka period of Japanese art history also derives its name from this. The Hoko-ji was greater in scale than the Shitenno-ji—or, for that matter, any of its contemporaries. The chronology given by the *Chronicles of Japan* is as follows: construction initiated in 588, Buddha hall and corridors built in 592, holy relics enshrined in the pagoda foundation in 593, construction completed in 596.

The temple was destroyed in a fire at the beginning of the Kamakura period (1185–1336), and, unlike the Shitenno-ji, was not rebuilt. However, excavations at the site in 1956–57 produced informative results. It was ascertained that the Hoko-ji had a centrally placed pagoda with not merely one, but three, main halls around it (Fig. 4). The surprising number of these halls in one compound is probably traceable to Paekche influence. There was an inner gate in the surrounding veranda corridors; and, as at the old Horyu-ji (Wakakusa-dera; see foldout plan facing page 24), the south gate of the temple was close to the inner gate. Again, like the old Horyu-ji, the Hoko-ji had a sutra repository, belfry, and lecture hall on the north, outside the compound.

The excavations in 1956–57 revealed the foundation stone that had borne the centerpost of the pagoda. The stone was some eight feet below the surface of the earthen base of the pagoda and had

5. Shaka Triad (623). Detail of Shaka's head. Bronze. Golden Hall, Horyu-ji. (See also Figures 6, 18, 22.) ▷

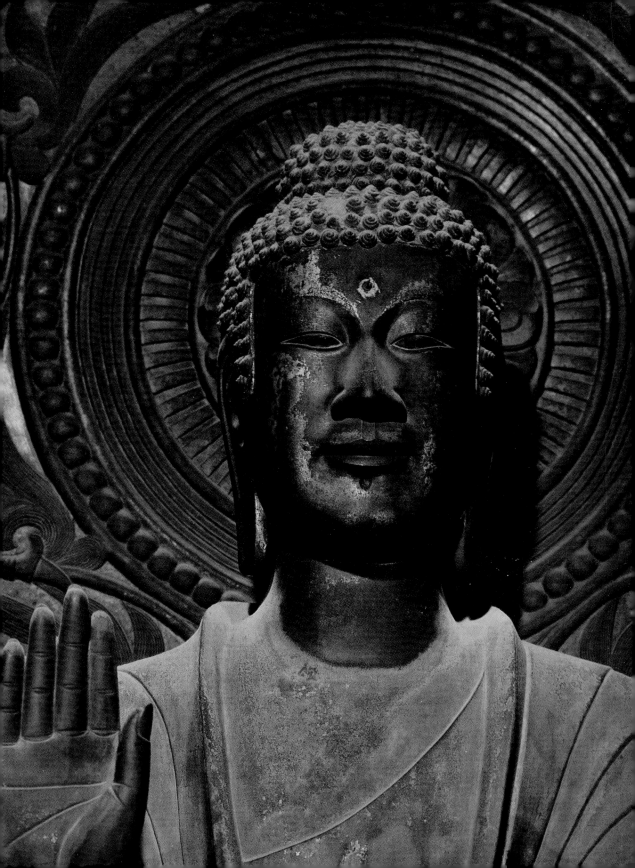

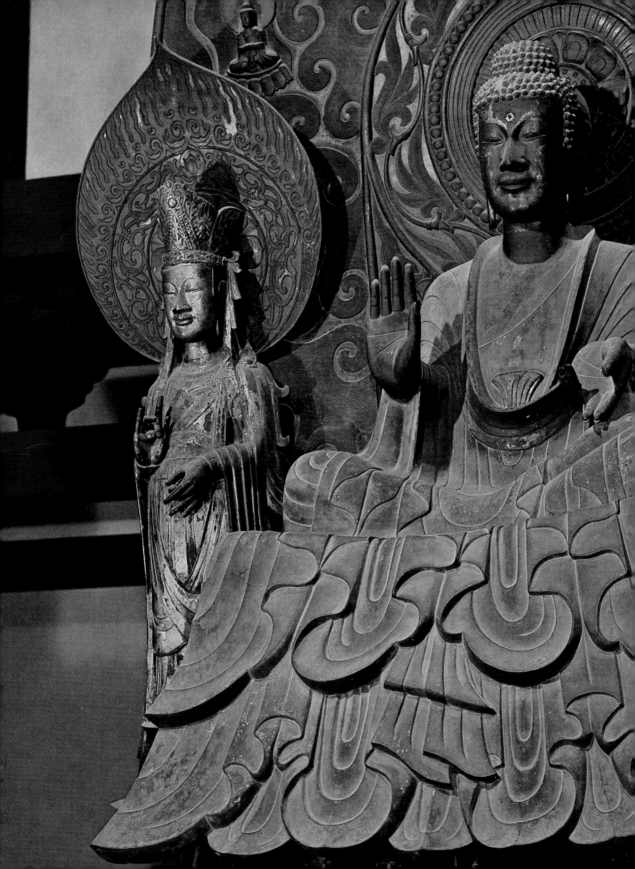

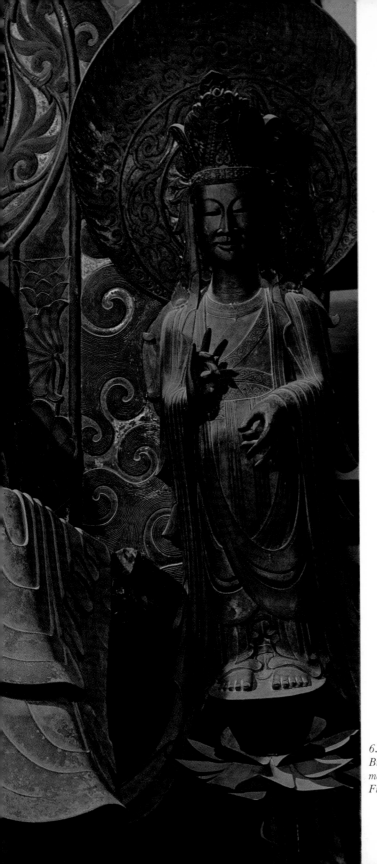

6. *Shaka Triad (623). Bronze; height of Shaka Buddha, 86.3 cm.; height of attendants, approximately 91 cm. Golden Hall, Horyu-ji. (See also Figure 18.)*

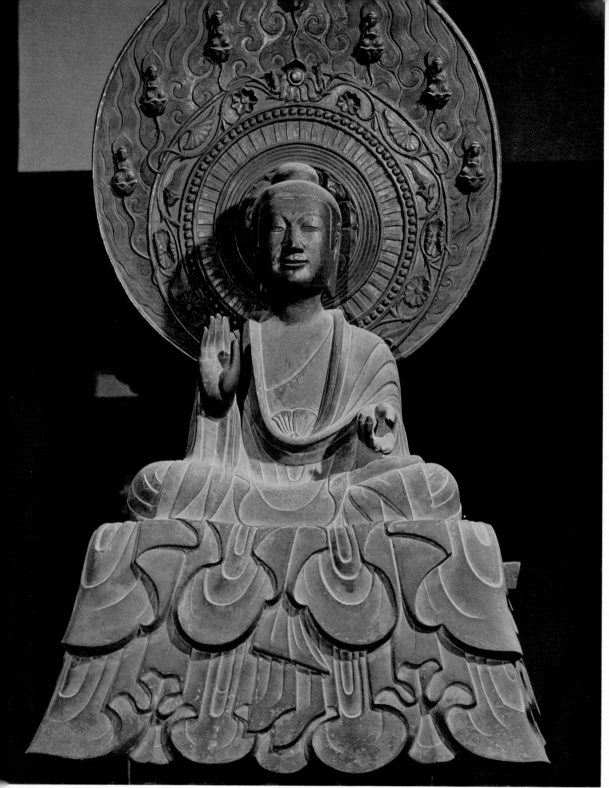

7. *Yakushi Buddha (second half of seventh century). Bronze; seated height of figure, 63 cm. Golden Hall, Horyu-ji. (See also Figure 29.)*

8. *Detail of canopy (second half of seventh century).* ▷
Wood; 244 × 244 × 217 cm. Golden Hall, Horyu-ji.

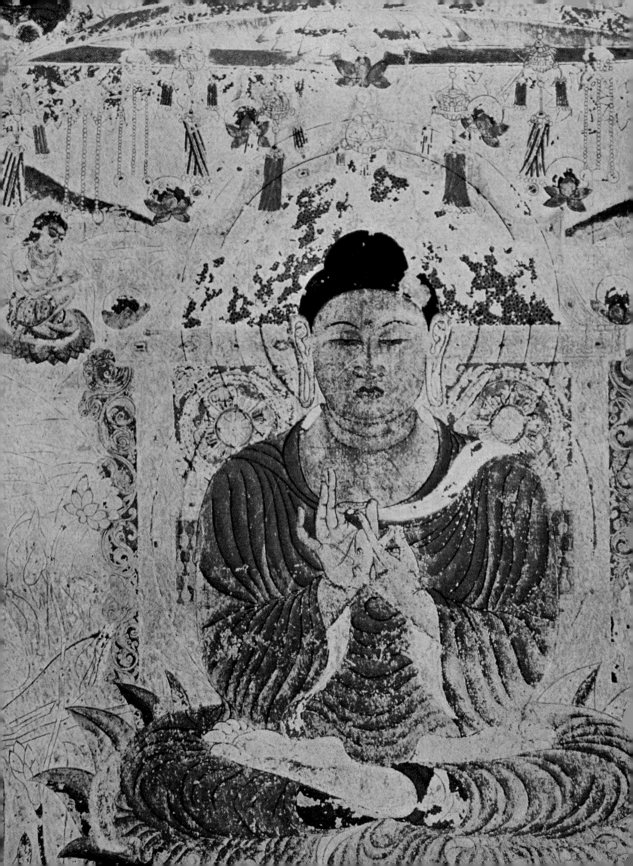

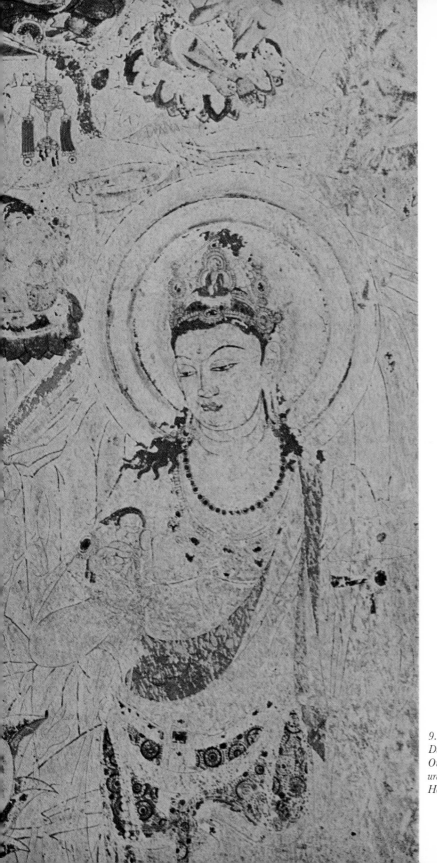

9. *Paradise of Amida Buddha (c. 700).*
Detail of mural on west wall (Panel 6).
Overall dimensions of painting (see Fig-
ure 132), 313 × 260 cm. Golden Hall,
Horyu-ji.

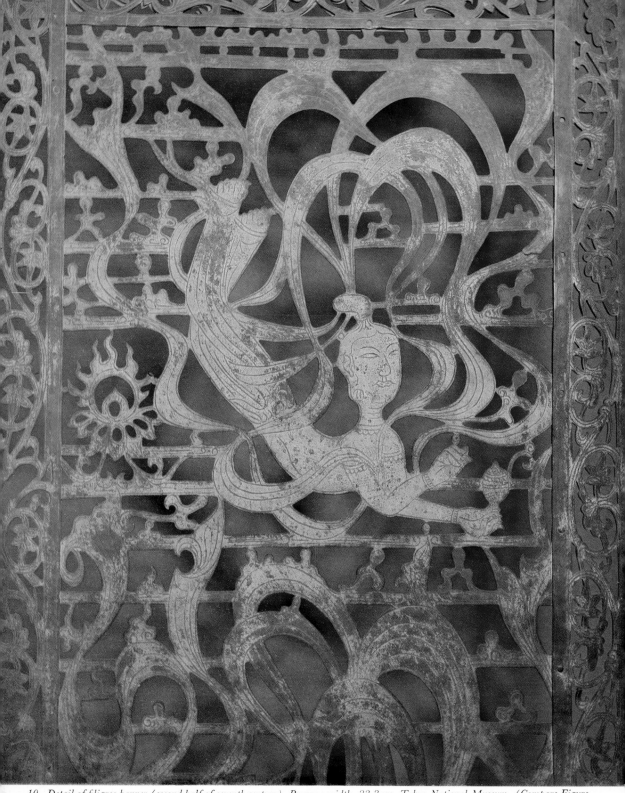

10. *Detail of filigree banner (second half of seventh century). Bronze; width, 33.3 cm. Tokyo National Museum. (Compare Figure 129.)*

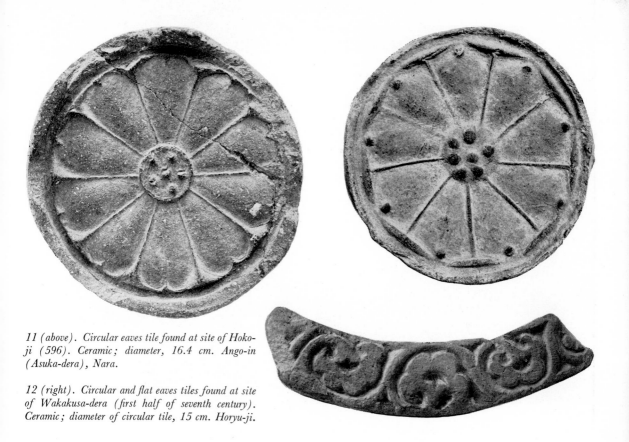

11 (above). *Circular eaves tile found at site of Hoko-ji (596). Ceramic; diameter, 16.4 cm. Ango-in (Asuka-dera), Nara.*

12 (right). *Circular and flat eaves tiles found at site of Wakakusa-dera (first half of seventh century). Ceramic; diameter of circular tile, 15 cm. Horyu-ji.*

in it a square hole with sides of some thirty centimeters and a depth of twenty centimeters. At the bottom of the east wall of this cavity was a niche serving as the relic chamber. Its surface was painted vermilion, and it was provided with a cover. The objects found in the relic chamber (actually not relics in the literal sense but relic substitutes) were not the originals but ones enshrined after the fire. They included gold and silver objects, curved ornaments known as *magatama*, horsebells, gilt-bronze fittings, and a model of armor. These artifacts resemble objects found buried in the funerary mounds of the Tumulus period, which extended over some three centuries preceding the Asuka period; and it is interesting to note that although they were placed in the foundation stone

much later, they still preserve the ancient style of the originals.

Since the Hoko-ji buildings burned down, not much remains to give information on the details of their wooden architectural members. Some roof tiles uncovered on the site, however, suggest a few things about the buildings. The roof tiling was in a style known as *gyokibuki*. The bottom course of tiles, or eaves tiles, had circular outer ends ornamented with simple lotus flowers, the petals of which were notched in a manner usually used for cherry blossoms (Fig. 11). These tile decorations clearly derive from Paekche architecture, and this fits in neatly with records stating that in 588, together with Buddhist relics and monks, craftsmen skilled in forging, painting, and tilemaking were

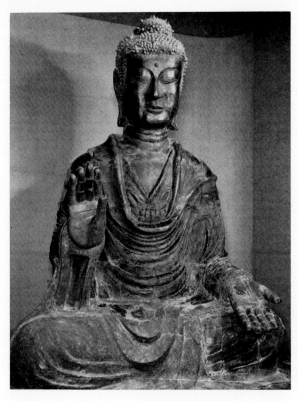

*13. Asuka Great Buddha (606). Bronze;
height, 275.7 cm. Ango-in (Asuka-dera),
Nara.*

sent to Japan from Korea. The rafters of the Hoko-ji were probably round, like the eaves tiles, and in all likelihood were set in the *hitonoki* system, which uses one set of rafters.

It is true that knowledge about the buildings themselves is skimpy, but excavations have shown that the temple was large and impressive. This is only to be expected, since the Hoko-ji was commissioned by a man of immense power—the Great Minister, Soga no Umako.

In 605, Empress Suiko, Prince Shotoku, Soga no Umako, and other high officials commissioned the famous sculptor Tori to create a large statue and a piece of votive embroidery for the Hoko-ji. Tori, the first great Japanese sculptor, was a leading member of the saddlers' guild (*kuratsukuribe*). His father Tasuna, the son of Shiba Tatto, had built

the Sakata-dera (also in Asuka village) and had made a wooden Buddha figure and attendants for this temple. After finishing the Buddha and embroidery for the Hoko-ji, Tori was commissioned to create the Shaka Triad (the historical Buddha Sakyamuni, founder of Buddhism, flanked by two attendants) at the Horyu-ji (Figs. 5, 6, 18). Since saddlemaking in those days entailed a knowledge of work in metal, wood, and dyeing, it is not surprising that saddlers should have been expert in statues in wood and cast bronze and in embroidery designs. They were also required to know how to use the sculptor's chisel, because, as in China and Korea at that time, cast-bronze statues were finished with extensive chiseling. In addition, they needed to know how to apply gold to their works by means of an amalgam process, for all bronze

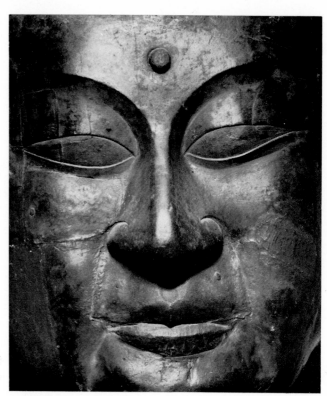

14. *Asuka Great Buddha (606). Detail of face. Bronze. Ango-in (Asuka-dera), Nara. (See also Figures 13, 50.)*

statues were treated in this way. Lacquering, too, was an essential skill, as wooden Buddhist statuary was always coated with lacquer. In short, the range of knowledge and skills demanded of these men was wide, and much of it was related to the kind of work done in making saddles. Of course, as important leaders in the saddlers' guild, both Tasuna and Tori doubtless had many helpers.

The Hoko-ji and the religion to which it was devoted came to enjoy great prestige among the aristocrats. In 594, an imperial edict was issued concerning reverence for the Three Treasures: the Buddha, the Teaching, and the Order. Tori's statue was dedicated in 606. At about the same time, three monks who had been ordained in Paekche returned to Japan, where they proceeded to conduct ordination ceremonies on their own. High offi-

cials began building temples in the capital and provinces. By 614, there were 46 temples and 1,385 monks and nuns in the country. In short, Buddhism had reached a flourishing state. The Hoko-ji may be interpreted as symbolic of this upward swing in the fortunes of the religion, since its very name means "the Law (Teaching) made prosperous."

The statue created for the Hoko-ji is called the Asuka Great Buddha (Asuka Daibutsu) and is now in the Ango-in on the site of the Hoko-ji. It and the Shaka Triad at the Horyu-ji are the only works definitely attributable to Tori, though traits characteristic of his style may be seen in other statues of the Asuka period. The Asuka Great Buddha (Figs. 13, 14) has been badly damaged and clumsily repaired. The original hands were probably not like the present ones, the positions of

which are suspect. Further, the three folds in the neck rarely occur in the sculpture of the Chinese Northern Wei period (386–534), which greatly influenced Tori's work. Nonetheless the curled hair, broad forehead, *byakugo* (an auspicious protrusion in the center of the forehead, one of the thirty-two outward signs of beauty believed to mark the body of Sakyamuni—or Shaka as he is known in Japanese), shoulders, almond-shaped eyes, and the region above the eyes are well done and in harmony with the sculpture of Tori's time. The figure is seated with both legs locked in the so-called lotus meditation posture (*kekkafuza*) typical of early Shaka statues. The draperies are long and flowing, like those of the Shaka Triad in the Horyu-ji Golden Hall (Figs. 5, 6).

Another important piece of sculpture showing the general characteristics of Asuka work is housed in the Treasure Museum of the Horyu-ji. It is a small (16.5 centimeters) triad called the Boshinen Shaka (Fig. 15), after the year *boshi* in the Chinese sexagenary cycle. In this year, 628 by Western reckoning, the statue was made for the Great Minister, Soga no Iname. Two attendants once flanked the central figure, though only one remains today. The engraving on the boat-shaped mandorla behind the figures is very beautiful. Because of the limited size of the statue, the curls of the headdress are merely suggested by means of intersecting horizontal and vertical grooves. The facial expression is gentle, the shoulders slope sharply, and the knees are held close to the body. The folds of the skirt belong to the tradition seen in the Horyu-ji Shaka Triad and in the Asuka Great Buddha. The extant attendant figure wears a three-peaked coronet with flowing ribbons. Its skirts flare symmetrically to right and left, and the figure stands on a lotus-blossom pedestal.

WAKAKUSA-DERA AND HORYU-JI

Having briefly outlined other temples and some of the major art works of the early Asuka period, I shall now turn to the Horyu-ji itself. During the reign of Empress Suiko—though the exact date is uncertain—Prince Shotoku built a palace at Ikaruga, overlooking the Yamato River,

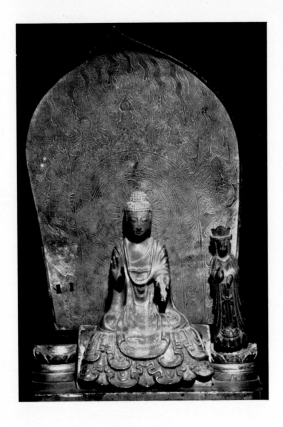

which drains the Yamato Plain and flows to Naniwa (Osaka). Prince Shotoku, as an avid scholar and Buddhist devotee, found Ikaruga convenient because it was near Naniwa, at that time the port of entry for knowledge and culture from the continent. In addition, however, it was the birthplace of one of his consorts. Adjacent to the Ikaruga Palace, the prince had a temple built. This temple, the Wakakusa-dera, no longer stands; but excavations of its site have produced interesting results. The main compound of the present Horyu-ji, which was once called Ikaruga-dera because of its location, stands to the northwest of the site of the Wakakusa-dera.

One of the things that excavations at the Wakakusa-dera have proved is the seniority of that temple over the Horyu-ji. Furthermore, it has been shown

15. *Boshinen Shaka (628). Bronze; height of seated Shaka, 16.5 cm. Treasure Museum, Horyu-ji.*

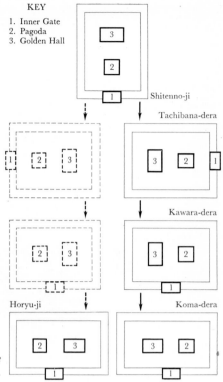

KEY
1. Inner Gate
2. Pagoda
3. Golden Hall

Shitenno-ji

Tachibana-dera

Kawara-dera

Horyu-ji

Koma-dera

16. *Diagrammatic representation of the development of the temple plan in Japan.*

that the Wakakusa-dera had a pagoda (with a square ground plan having sides of 13.5 meters) and a main hall (with a plan of 22×19.5 meters). The two buildings were arranged in a straight north-south line, in a layout that follows the older tradition of the Shitenno-ji. Neither the Hoko-ji nor the Horyu-ji adhered to this traditional placement. The sizes of the Wakakusa-dera pagoda and main hall were roughly equivalent to those of the corresponding buildings at the Horyu-ji, but the line on which they stood was about twenty degrees west of magnetic north. Although orthodox tradition stressed north-south axes and south orientation of major temple compounds, the Wakakusa-dera deviates in order to be almost parallel with the Ikaruga Palace, its neighbor on the east. The fact that the Horyu-ji faces directly south indicates that

it was built later than the Wakakusa-dera. In other words, Buddhist orthodoxy determined the layout of the Horyu-ji, whereas the older Wakakusa-dera could not be planned in perfect south orientation because of the placement of the neighboring palace.

Pagodas generally have central foundation stones. A stone of this kind was found on the site of the Wakakusa-dera, and examination of it showed that the hole in which the centerpost of the upper structure rested was cut to accommodate splice plates. The post itself was octagonal in cross section. A similar structural device is employed in the Horyu-ji pagoda.

A great deal of scholarly contention has raged around the dating of these two temples, with little totally convincing evidence advanced in any one argument. It can be stated with reasonable cer-

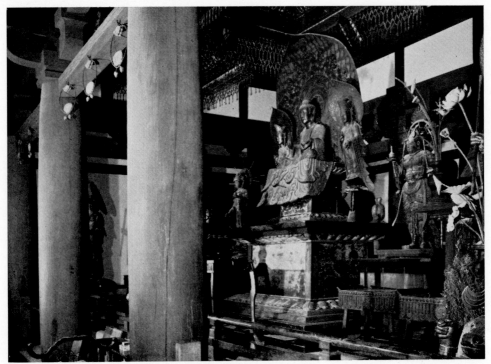

17. *Inner sanctuary of the Golden Hall, Horyu-ji. (See also Figure 97.)*

tainty, however, that a man of Prince Shotoku's pious reputation would have built a temple at his palace; consequently, it can be assumed that the Wakakusa-dera was constructed during his lifetime. Excavated roof tiles from the Wakakusa-dera and other sites provide further grounds for approximate dating. For instance, tiles from the Wakakusa-dera (Fig. 12) closely resemble ones found at the Hoko-ji and other temple sites in the same region.

This suggests that, after official recognition was granted to Buddhism, a wave of temple building swept the district. Most of the temples employing the same kind of roof tiles were probably erected within a fairly short period of time. Tiles from the Wakakusa-dera and other sites differ from those used at the present Horyu-ji in that their designs are simpler. Crescent-shaped edging tiles, orna-

mented with a pattern of ginkgo leaves, have been found at the Wakakusa-dera but have never been uncovered at the Hoko-ji. Assembling the available evidence, one can say with assurance that there have been two temples in the vicinity of the site of Prince Shotoku's Ikaruga Palace and that the Wakakusa-dera is older than the existing Horyu-ji. Obviously each of the temples had a main image, presumably the Shaka Triad (Figs. 5, 6, 18) and the Yakushi (Figs. 7, 29) now housed in the Horyu-ji Golden Hall. Which of these was the original principal image of the older temple, however, remains an unsettled question.

SHAKA AND YAKUSHI In the Horyu-ji Gold-
en Hall today, the Sha-
ka Triad and Yakushi statues, both in bronze,

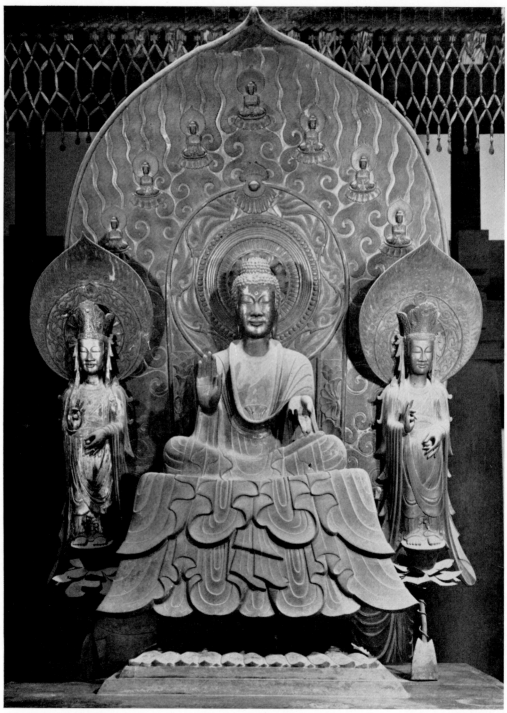

18. Shaka Triad (623). Bronze; height of Shaka Buddha, 86.3 cm.; height of attendants, approximately 91 cm. Golden Hall, Horyu-ji. (See also Figure 6.)

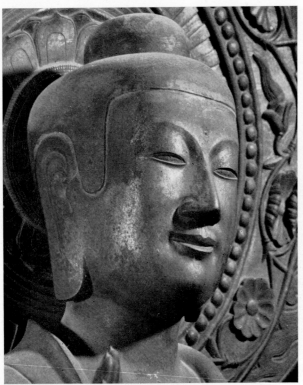

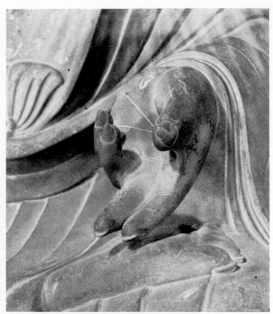

20. *Yakushi Buddha (second half of seventh century). Detail showing left hand in wish-granting (yogan) mudra. Bronze. Golden Hall, Horyu-ji. (See also Figures 7, 29.)*

19. *Yakushi Buddha (second half of seventh century). Detail of head. Bronze. Golden Hall, Horyu-ji. (See also Figures 7, 29.)*

stand side by side. Neither is directly on the main axis of the building, where a principal icon ought to be. The Shaka Triad, the central figure of which is said to have been made to the dimensions of the body of Prince Shotoku, is perhaps too small to be the principal object in a room as large as the Golden Hall. But the heavily ornamented canopy (Fig. 8) and the massive double pedestal (Fig. 17) on which it rests to some extent restore the balance with the surrounding space.

On the mandorla behind the figure of Shaka and two attendants is an inscription relating the events leading to the production of the group. In 621, Anahobe no Hashihito, who was Emperor Yomei's consort and Prince Shotoku's mother, died. In the following year Prince Shotoku and one of his consorts fell ill. Empress Suiko, imperial princes, and high officials commissioned the sculptor Tori to make a statue to the size of the prince's body. This statue was to serve as a votive offering for his recovery, or, in the event of his death, for rebirth in the Buddhist paradise. On February 11 of the same year, Shotoku's consort died, and he himself succumbed on the following day. The statue, however, was finished and was dedicated with solemn ceremony in 623. That statue is the Shaka Triad in the Golden Hall of the Horyu-ji.

The statue of Yakushi (the Buddha of healing), too, bears an inscription. The information on the back of this figure states that the statue and a tem-

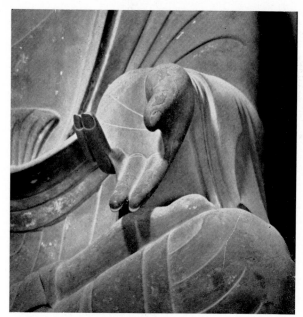

21. *Shaka Triad (623). Detail showing Shaka's left hand in wish-granting (*yogan*) mudra. Bronze. Golden Hall, Horyu-ji. (See also Figures 6, 18.)*

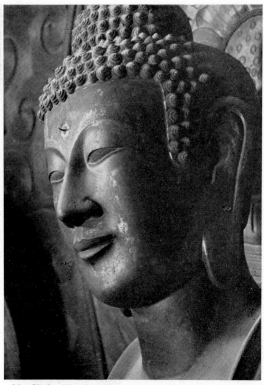

22. *Shaka Triad (623). Detail of Shaka's head. Bronze. Golden Hall, Horyu-ji. (See also Figures 5, 6, 18.)*

ple were commissioned as a votive offering for the recovery from illness of Emperor Yomei, who, upon falling ill in 586, called Kashigiyahime (widow of Emperor Bidatsu, and the future Empress Suiko) and Prince Shotoku to his bedside and requested that they commission a statue and a temple to house it. The pious request produced no improvement in the health of the emperor, who died soon thereafter. Kashigiyahime and Prince Shotoku nonetheless resolved to fulfill the late ruler's wishes. In 607, both the temple and the statue were finished.

If all the information on the statue is reliable, dating seems simple: the Yakushi statue is obviously older and may therefore have been the main image in the Wakakusa-dera, which could well be the temple ordered to be built to house the statue. However, the question of which of the statues is the original main icon of the temple has been disputed for many years. Some scholars have argued that in points of linguistic usage, reign-period designations, and honorific ways of referring to Prince Shotoku that would be inappropriate if applied to a living person, the inscription on the Yakushi is erroneous. Some critics claim that the worship of Yakushi could not have been sufficiently widespread at so early a time to warrant the use of a statue of that deity as the principal object of veneration in a temple. Others have argued that, if the Yakushi is the true main icon, it ought to be placed on the

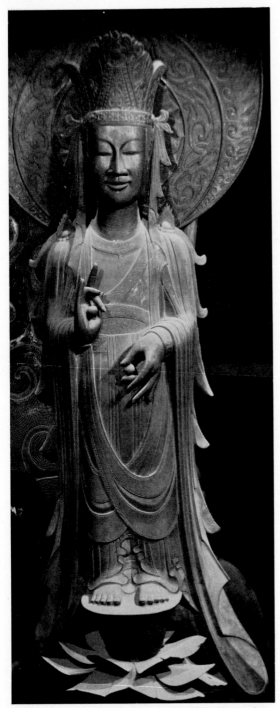

24. *Shaka Triad (623). Rubbing of coronet of left-hand attendant. Actual coronet of bronze. Golden Hall, Horyu-ji.*

central axis of the room. This argument has been countered, however, with the assertion that the greater size of the Shaka Triad demands a prominent position. The inscription on the Shaka Triad, as well as that on the Yakushi statue, has been attacked as conducive to misinterpretation. In short, on the basis of the inscriptions alone, it seems impossible at present to come to a definite conclusion on the matter. A detailed descriptive comparison of the two statues, however, provides some basis for making a judgment.

The central figure of the Shaka Triad, Shaka (Sakyamuni), is both serene and severe in mood. The face is distinctly non-Japanese in appearance (Figs. 5, 22). The nose and neck are long, and the

23. *Shaka Triad (623). Detail of right-hand attendant. Bronze; height, 90.7 cm. Golden Hall, Horyu-ji. (See also Figure 6.)*

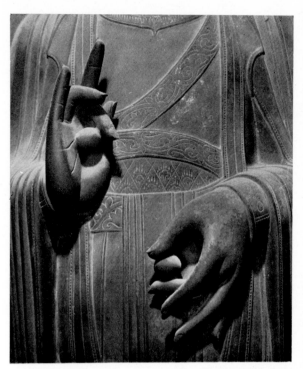

25. Shaka Triad (623). Detail showing hands of right-hand attendant. Bronze. Golden Hall, Horyu-ji.

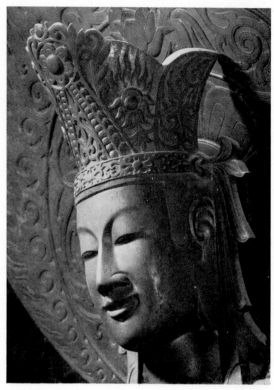

26. Shaka Triad (623). Detail showing head of right-hand attendant. Bronze. Golden Hall, Horyu-ji.

lips are firmly closed. The major compositional elements of the figure are the head, neck, and trunk. The gentle eyes, which are the same almond shape found in the Asuka Great Buddha, gaze calmly from beneath the broad forehead and elaborately curled hair. This characteristic eye shape consists in a curved lower lid rising to the outer corner. The large, triangular nose and thick lips contribute to the foreign appearance. The vertical groove in the upper lip and the dimplelike depression under the lower one are well defined and deep. The *byakugo* protrusion on the forehead has been lost; only the spike to which it was attached remains.

The mandorla behind the three figures is especially effective. The central circle, almost entirely concealed behind the head of Shaka, is composed of a lotus blossom (Figs. 5, 18, 30). On the periphery of this circle are a ring of radial ribbing and another of concentric grooves. The tight geometric composition of this part of the mandorla is completed by a ring of hemispherical jewels and another ornamented with vines and leaves. The overall design exhibits an unparalleled grandeur. The innermost circle is fitted into the top of a large, roughly parabolic section, the lower parts of which are ornamented with lotus leaves and blossoms. The curves of the vines and leaves are stronger, though less free, than similar designs found in Chinese sculpture. The surfaces of the leaves are filled with beautifully executed parallel grooves. At

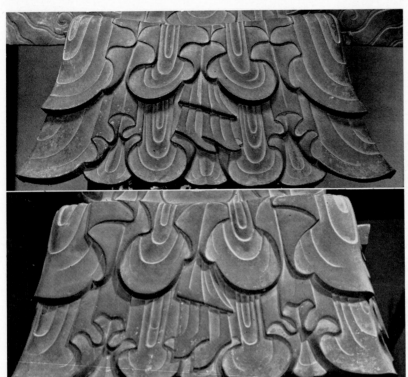

27 (top). Shaka Triad (623). Detail showing skirt draperies of Shaka Buddha. Bronze. Golden Hall, Horyu-ji. (See also Figures 6, 18.)

28 (bottom). Yakushi Buddha (second half of seventh century). Detail of skirt draperies. Bronze. Golden Hall, Horyu-ji. (See also Figure 7.)

the pinnacle of the parabola is a *mani* jewel, the ever-luminous pearl that is a symbol of the Buddha. The broad outer part of the mandorla is filled with flame shapes—swirling spirals at the bottom extending into undulating tongues of fire above. The surfaces of the flames are filled with parallel grooves as skillfully done as as those in the leaves in the inner section of the mandorla. Seven small Buddhas with childlike, innocent faces are ranged along the outer segment of the mandorla. Though the lotus leaves and blossoms in the vertical segments of the inner parabola are not entirely satisfying, they strongly recall the style of the Chinese Northern Wei period (386–534).

The right hand of Shaka is lifted to chest height and is turned palm outward in the *semui no in,* or "reassurance" mudra (symbolic gesture). Though lovely, the hand is somewhat rigid in feeling. The left hand, in the "wish-granting" mudra (*yogan no in*), reveals the interdigital webbing that, like the *byakugo* in the forehead, is one of the thirty-two physical attributes of Shaka.

The figure is seated in the lotus meditation posture with the legs forming a saddle-shaped depression. The beautifully arranged folds of the skirt of the outer garment flare to the right and left as they descend to the lotus throne on which the figure rests. The simplicity of the monk's garb heightens the magnificence of the total impression. One ornamental touch is supplied by the small, delicately designed sash end at the chest, thrusting upward between the heavy outer robe and the lighter, diagonally open inner garment.

Two attendant figures to the right and left of

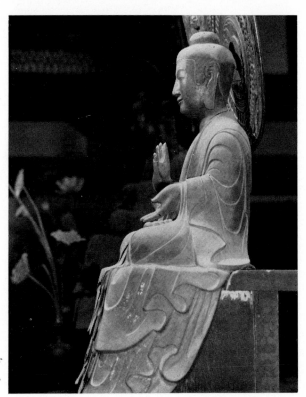

29. *Yakushi Buddha (second half of seventh century). Bronze; height of figure, 63 cm. Golden Hall, Horyu-ji.*

Shaka rise in stately fashion from lotus pedestals resting on the lower of the two wooden altar sections. Often total compositional symmetry is achieved in groups of this kind by having one attendant raise the right hand and the other the left. In this case, however, both statues raise the same hand, thus upsetting the symmetry (Figs. 6, 18). All three figures were once gilded, though most of the gilt has flaked away from Shaka and the attendant on his left (Fig. 23). The faces of the smaller statues resemble that of the Shaka, but the eyes are slightly narrower. The heavy downward-flowing lines of their robes are balanced by the soaring points of the coronets, which are of an ancient, triple-peak form (Figs. 24, 26). The central peak is flanked by two lower side wings. Between the central and side points are *mani* jewels. Within the triangular front peak and around its upper part are scroll ornaments (*karakusa*). At the pinnacle of the center peak is a circle enclosing a six-petal lotus. The crescent and circle at the top of the coronet are said to be design elements derived from the crowns of the Sassanian kings of Persia. The flame forms filling the side wings of the coronets are related to patterns found in artifacts excavated from ancient Japanese grave mounds. The band of each coronet, ornamented with a series of four-armed scroll motifs, drops at the ends and descends in streamers to the shoulders, where there are *mani* jewels. From the shoulders, the draperies fall in outward-flaring lines. The hands—one turned up, the other turned down—are held at about hip level. Each hand holds a jewel (Fig. 25), an unusual addition to statues of this kind.

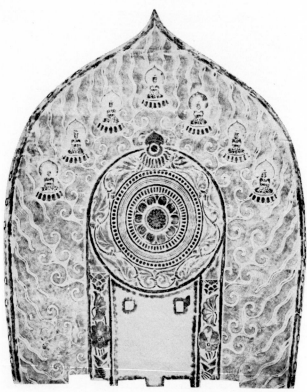

31. *Shaka Triad (623). Detail of Shaka's mandorla showing relief Buddha figure. Bronze. Golden Hall, Horyu-ji. (See also Figure 18.)*

30. *Shaka Triad (623). Rubbing of Shaka's mandorla. Actual mandorla of bronze; height, 175.6 cm. Golden Hall, Horyu-ji. (See also Figures 6, 18.)*

There is a mandorla behind each of the attendant figures. The central portion of the mandorla is filled with an unusual double lotus blossom. Beyond the flower are a ring of cloud-and-scroll patterns and a pointed outer part filled with flame forms (Figs. 18, 23).

The statue of Yakushi, located to the right of the Shaka Triad, lacks the small jar of medicine characteristic of this Buddha. Consequently, on the basis of physical examination alone it would be impossible to say that this is in fact a statue of Yakushi and not one of Shaka. Fortunately, however, the inscription on the back of the mandorla clearly says that this is an image of Yakushi and that it was made in the fifteenth year of the reign

of Empress Suiko (607). I have already outlined the controversy surrounding this date. But an examination of the statue, against a background of the information set forth about the Shaka Triad, sheds some light on the dating problem.

The Shaka and Yakushi resemble each other to the smallest details (Figs. 6, 7, 18, 29). There are, however, minor differences. For instance, the folds of the skirt of Shaka (Fig. 27) are larger and more numerous than those in the figure of Yakushi (Fig. 28). Furthermore, there is one more horizontal ripple in each fold of Shaka's skirt, and this additional ripple is present in all folds, including the short central ones. The central folds of the Yakushi skirt are slightly unnatural in appearance. This

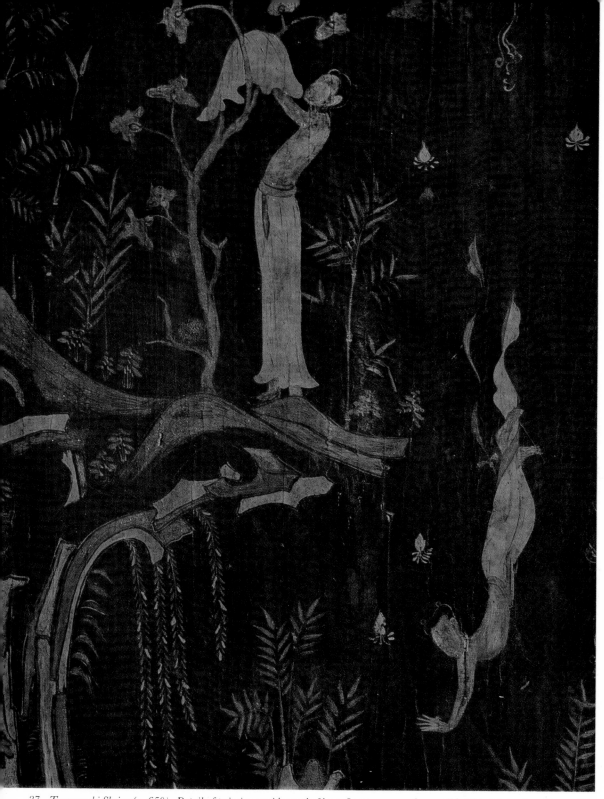

37. *Tamamushi Shrine (c. 650). Detail of painting on side panel of base. Lacquer on wood; overall height of shrine (see Figure 43), 232.7 cm. Treasure Museum, Horyu-ji.*

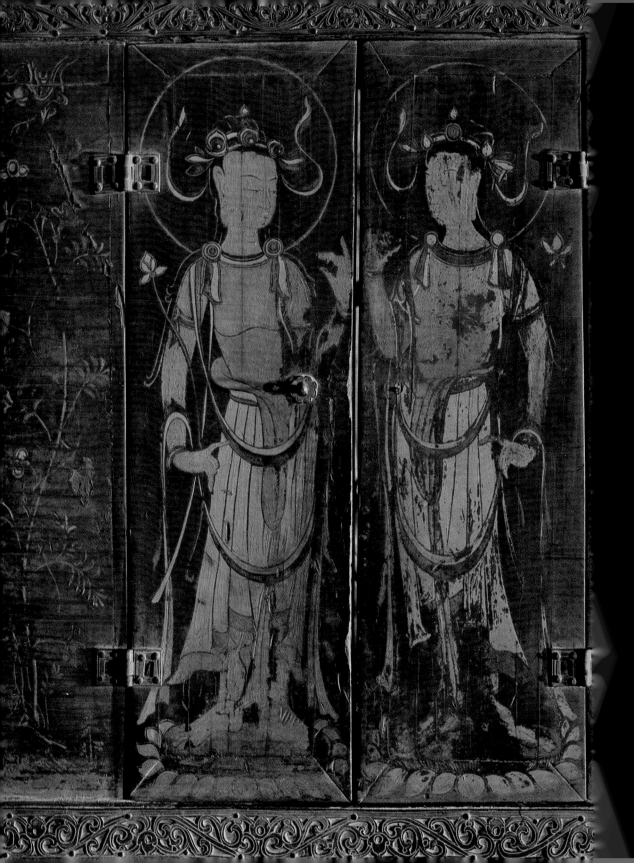

38. Tamamushi Shrine (c. 650). Detail of side door panels of shrine showing two Bodhisattvas. Lacquer on wood; overall height of shrine (see Figure 43), 232.7 cm. Treasure Museum, Horyu-ji.

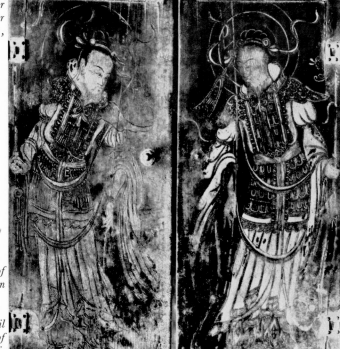

39 (right). Tamamushi Shrine (c. 650). Detail of front door panels showing divine kings. Lacquer on wood. Treasure Museum, Horyu-ji.

40 (below). Tamamushi Shrine (c. 650). Detail showing painting of Mount Ryoju on back panel of shrine. Lacquer on wood. Treasure Museum, Horyu-ji.

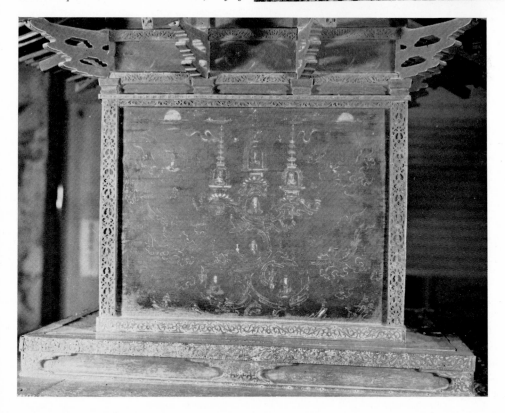

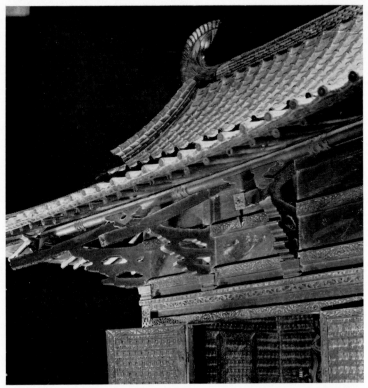

41. *Tamamushi Shrine (c. 650). Detail showing "Thousand Buddhas" in bronze repoussé on inside of front door panel. Treasure Museum, Horyu-ji.*

42. *Tamamushi Shrine (c. 650). Detail showing eaves and bracketing. Wood. Treasure Museum, Horyu-ji.*

and-gabled (*irimoya*) type, is covered with tiles set in the *shikorobuki* style, with a sharp break between the upper and lower levels of the roof. The tiles are placed in the same *gyokibuki* style that I discussed in connection with the Hoko-ji. (See page 25.) The purlins and rafters are round in cross section, the eaves are of the single-rafter (*hitonoki*) type, and so-called cloud corbels (Fig. 42) support the eaves. Although the corner rafters of the shrine are not placed in radial setting, it has been shown by excavations at the Shitenno-ji that radial placement was common in the Asuka period. Furthermore, a radial arrangement was frequent in rafters of very old Chinese buildings. The parallel setting used in the Tamamushi Shrine must have been

dictated by the reduced size of a model building. A flight of steps leads to the front of the shrine. The posts are square in section and are capped with bearing blocks (*daito*). There are double-leaf doors on three sides. These doors and the major flat surfaces of the upper section of the pedestal are ornamented with lacquer paintings. The pedestal is decorated with heavy lotus-petal molding (Fig. 34).

The architectural details of the Tamamushi Shrine belong to an unadulterated old style that predates the building of the present Horyu-ji. In fact, the shrine and the Horyu-ji Golden Hall and Pagoda differ considerably on a number of stylistic points. A definite date for the Tamamushi Shrine is

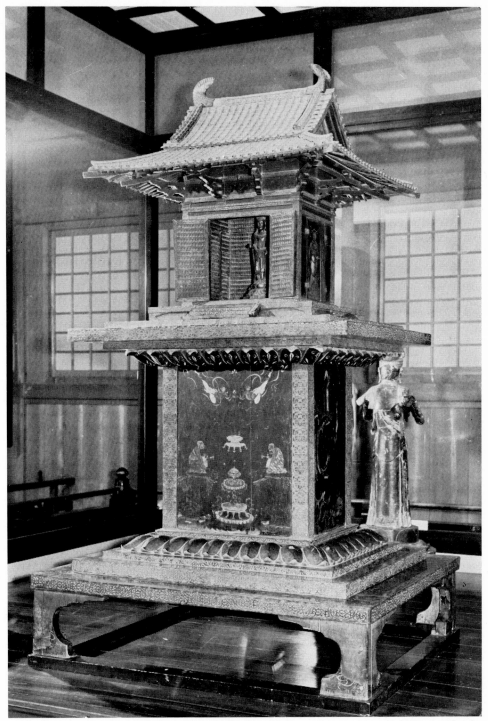

43. Tamamushi Shrine (c. 650). Wood; overall height, 232.7 cm. Treasure Museum, Horyu-ji. (See also Figures 35–38.)

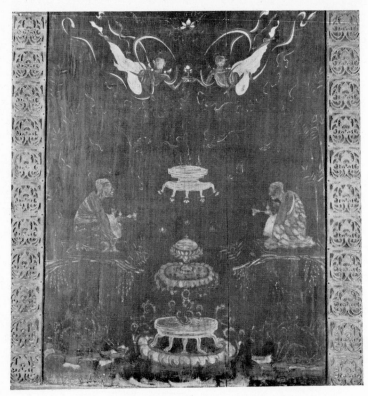

44. *Tamamushi Shrine (c. 650). Detail of front panel of base showing relics, monks making incense offerings, and flying angels. Lacquer on wood. Treasure Museum, Horyu-ji. (See also Figure 43.)*

difficult to state, though indications of comparative age can be seen. The molding on the shrine is weaker in feeling than similar decoration on the pedestal of the Shaka Triad in the Horyu-ji Golden Hall (Fig. 17). For this reason, I assume that the temple predates the shrine, though the shrine represents an older architectural style. The lavish filigreed bronze fittings on the Tamamushi Shrine resemble similar decoration on the Yumedono (Guze) Kannon and Four Celestial Kings (Figs. 51–54). I believe, therefore, that the shrine was made at the same time as the statues—that is, the late Asuka period.

At present, the shrine houses a small statue of the Bodhisattva Kannon (Avalokitesvara). The multitude of small embossed Buddha-figures on the doors and walls of the interior, however, suggests that the original image was a figure of Shaka. The Kannon was probably placed in the shrine in the Hakuho period.

Some specialists assert that the pictures on the shrine are executed in a technique called *mitsuda*, which employs a mixture of lead oxide and oil. Others argue that they are done in lacquer. I agree with the latter opinion. The guardian figures on the front panel (Fig. 39), presumably two of the Four Celestial Kings since they wear armor similar to that generally found on statues of these divinities, stand with hips thrust outward and with heads turned to one side in a pose reminiscent of Indian art. The slender halberds they hold are painted in a fine, even line known as the wire line, but for the main part a rhythmically modulated line rich in variety is employed.

Bodhisattvas ornament the side panels of the shrine (Fig. 38). The tall, slender figures standing

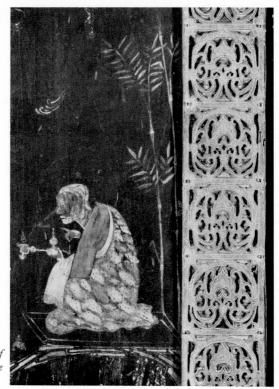

45. *Tamamushi Shrine (c. 650). Detail of front panel of base showing bronze filigree decoration. Treasure Museum, Horyu-ji.*

on lotus-blossom pedestals are naked to the waist, but flowing skirts and draperies clothe their lower bodies. One hand of each figure forms a *mudra;* the other hand holds a flowering lotus stalk. Their coronets consist of three *mani* jewels attached to a band from which ribbons flow outward to right and left. There are mandorlas behind their heads. The pleats of the skirts are regularly arranged, though they manifest the slight right and left outward flare reminiscent of Chinese Buddhist sculpture of the Eastern Wei period (534–50). On the panels beside the doors are beautiful plants and *mani* jewels trailing flames as they apparently fly through the air. It is not certain which of the Bodhisattvas in the Buddhist pantheon these elegant and graceful saintly figures represent.

On the back of the shrine is a depiction of a mountain. One chapter of the *Lotus Sutra* recounts how four disciples of Shaka are promised enlightenment in a future life, and since this painting shows four caves in the mountain with a Buddhist monk seated in each of them, it is regarded as a representation of Mount Ryoju (Grdhrakuta), where Shaka preached the *Lotus Sutra*. On top of three pinnacles there are three pagodas housing one Buddha each. These are probably representations either of the three major divisions of Buddhist teaching, as expounded in the *Lotus Sutra,* or of the three stages of expounding the teaching—by theory, by parables, and by the life stories of previous Buddhas. The standard representations of Mount Ryoju show the Tahoto (Precious Pagoda), which, according to another chapter of the *Lotus Sutra,* sprang up out of the mountain as Shaka preached. However, the pagoda is absent in this painting.

The four sides of the upper section of the pedestal,

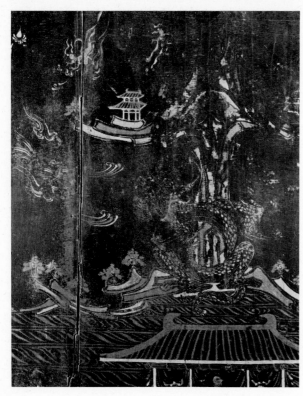

46. Tamamushi Shrine (c. 650). Detail of Dragon King's palace, from back panel of base. Lacquer on wood. Treasure Museum, Horyu-ji.

too, are decorated with paintings. The front, ornamented with representations of the sacred relics of the Buddha (Fig. 44), is divided into upper, middle, and lower zones. In the central zone is a sacred incense burner flanked by two kneeling Buddhist monks holding long-handled censers (Fig. 45). In the bottom zone is a relic tower with lions on either side. Two angels holding a Chinese-style incense burner grace the top zone.

On the back of the pedestal is a representation of Mount Sumeru, the central peak in the universe, according to Buddhist cosmology. On the pinnacle of the mountain is the paradise of Indra (Taishaku Ten), and on four promontories beneath it are the palaces of the Four Celestial Kings of the cardinal points. At the base of the mountain dwell two dragons. To the right and left of Mount Sumeru are the sun and the moon, flying horses, angels,

phoenixes, holy men astride birds, and scudding clouds. In the expanse of sea spreading at the bottom of the mountain is a palace housing a seated figure. A dragonlike beast surmounts the building. In the right and left corners of the panel are boulders surmounted by dragons and phoenixes.

On the left panel of the pedestal is a picture depicting the virtuous acts of a Bodhisattva who sacrifices himself for the sake of all humanity (Figs. 37, 48). The panel is half filled with a mountain covered with bamboo, grasses, and vines. On one projecting point, a Bodhisattva is removing his upper garment and hanging it on a tree. To the right and below this picture, the Bodhisattva is shown throwing himself from a cliff. At the base of the mountain a ravenous tigress and her cubs are devouring his flesh. The immediate source for this

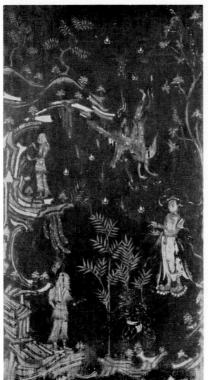

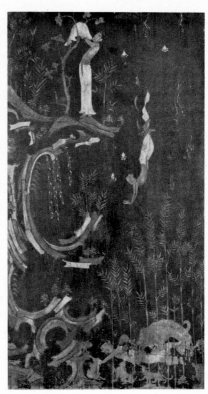

47 (right). *Tamamushi Shrine (c. 650). Detail of side panel of base. Lacquer on wood. Treasure Museum, Horyu-ji. (See also Figure 36.)*

48 (far right). *Tamamushi Shrine (c. 650). Detail of side panel of base. Lacquer on wood. Treasure Museum, Horyu-ji. (See also Figure 37.)*

pictorial parable is the *Konkomyo-kyo* (Sutra of the Golden Light). On the right side of the pedestal is a painted version of a tale from the *Daihan Nehan-kyo* (Sutra of the Great Nirvana) about the Buddha during a former life, when, as a Brahman, he was undergoing training in the mountains (Figs. 36, 47). Indra (Taishaku Ten) appeared to him in the guise of a demon and recited half of a stanza of scripture: "All things are impermanent; this is the law of coming into being and cessation." On hearing this, Buddha rejoiced and pleaded with the demon to complete the stanza. Should the demon grant this wish, the Buddha promised to throw himself from the cliff on which he stood and sacrifice himself to the demon. The disguised Indra, who was testing the Buddha's virtue, replied: "Only when coming into being and cessation are extinguished is the bliss of Nirvana attained." The

Buddha then inscribed the stanza on the cliff and on a tree and, in fulfillment of his promise, threw himself from the cliff. But at this point, Indra appeared in his true form and caught the Buddha as he fell. The composition of this panel resembles that of the one on the other side of the pedestal: in one the Bodhisattva removes his upper garment and hangs it on a tree before leaping from the cliff; in the other the Buddha is shown inscribing scripture on a tree before hurling himself into the abyss. Similarly, in the lower right of one panel the tigress and her cubs are busy at their grisly meal, while, in a similar location in the composition of the other panel, Indra waits to save the falling body of the Buddha.

The treatment of the cliff, leaves, plants, and clouds of both pictures immediately suggests the influence of Northern Wei Chinese art. We have no

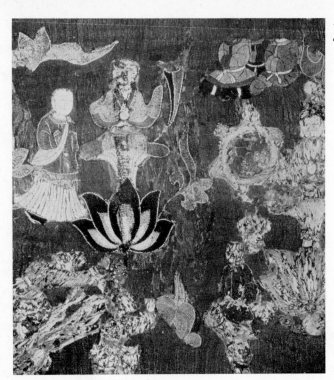

49. *Detail of Tenjukoku Embroidered Mandala (623).*
Silk. Chugu-ji, Nara.

50. *Asuka Great Buddha (Shaka Buddha; 606). De-* ▷
tail of head. Bronze; height (see Figure 13), 275.7 cm.
Ango-in (Asuka-dera), Nara. (See also Figure 14.)

other example of Japanese painting from the Asuka period, though the piece of textile known as the Tenjukoku Embroidered Mandala offers some hints about the nature of pictorial art of the age.

TENJUKOKU EMBROIDERED MANDALA

The *Chronicles of Japan* states that, together with the Asuka Great Buddha, an embroidered banner was commissioned and made for the Hoko-ji. The same work makes mention of other, similar pieces of Buddhist embroidery, though none of them are extant today. In her grief over the death of her lord, Prince Shotoku's consort Tachibana no Oiratsume asked Empress Suiko for permission to have the Tenjukoku Embroidered Mandala made (Fig. 49). This was in 622. Since the fabric is badly decomposed, it is impossible to surmise what the original two panels of the work were like; but it is said that they depicted Prince Shotoku in paradise. Bright red, green, and other colors are used to depict temples, belfries, Bodhisattvas, demons, monks, male and female members of the laity, phoenixes, the traditional Japanese rabbit-in-the-moon motif, scudding clouds, and beings on lotus blossoms. The patterns are skillfully devised and combined. The trousers tied with sashes worn by the men and the skirts and loose upper garments of the women resemble fashions illustrated in murals of the Korean kingdom of Koguryo. Although at a glance the facial expressions seem childish, so little of them remains that it is impossible to make detailed comment. Some of the design motifs probably originated in the Sui period (589–618) in China, but the design ideas were soon transferred to Korea. This, combined with mention—in an ancient document about Prince Shotoku and the religious faith that developed around him—of a group of naturalized Korean craftsmen, indicates that perhaps such men were reponsible for the design of the embroidery.

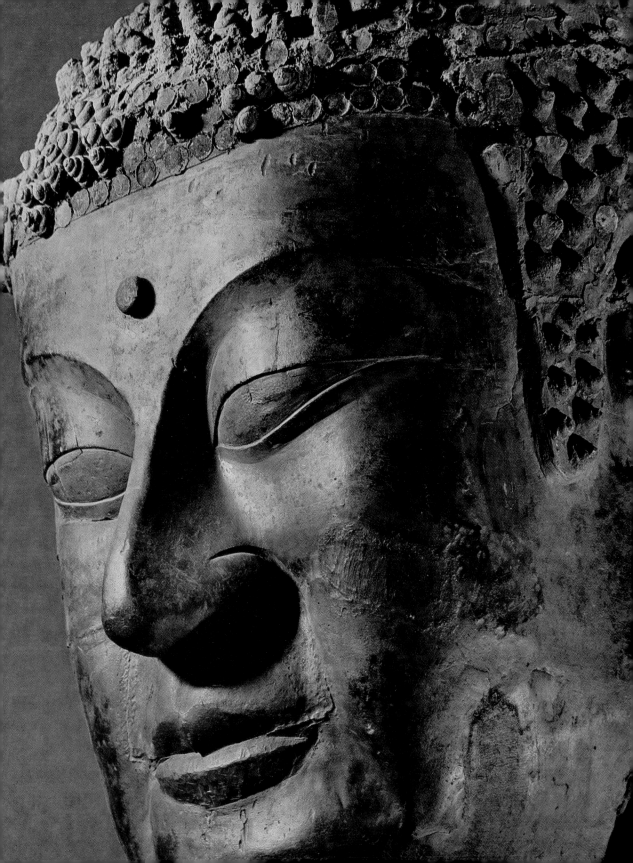

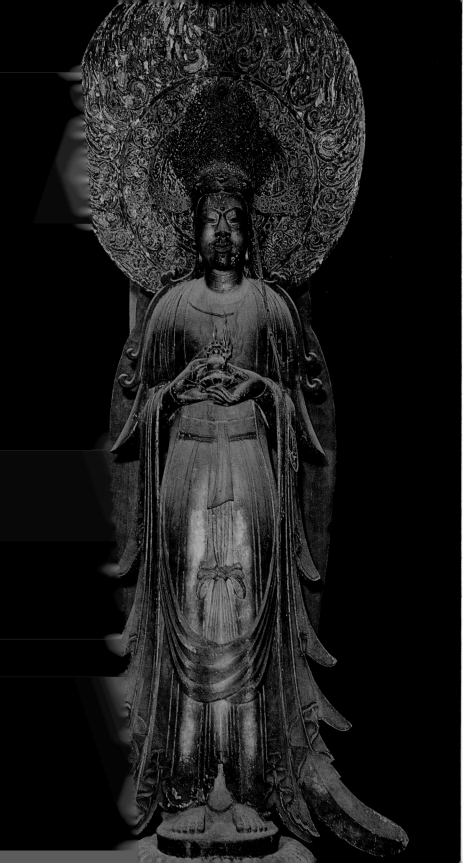

51, 52. *Yumedono Kannon (first half of seventh century). Wood; height of figure, 179.9 cm. Yumedono, Horyu-ji. (See also Figure 69.)*

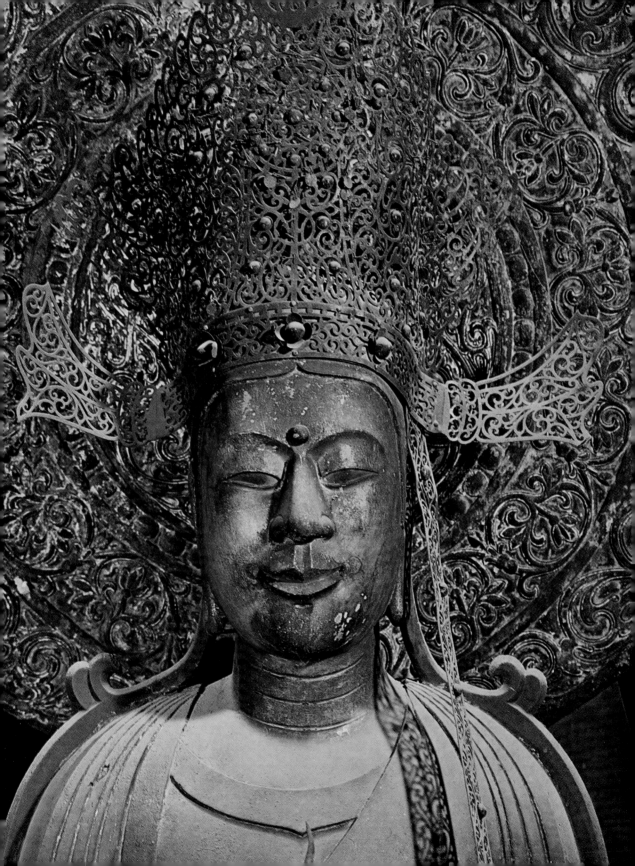

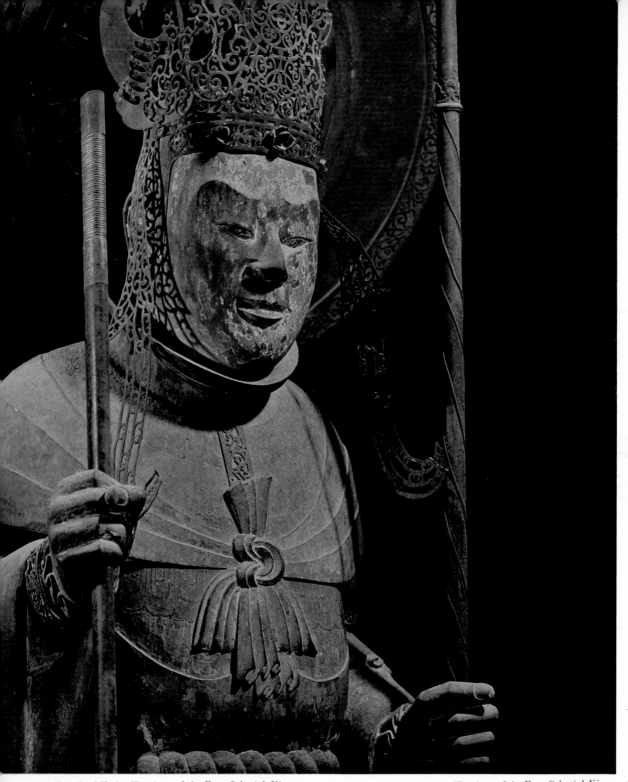

53. *Detail of Zocho Ten (one of the Four Celestial Kings; c. 650). Wood; overall height of figure, 133 cm. Golden Hall, Horyu-ji.*

54. *Detail of Komoku Ten (one of the Four Celestial Kings; c. 650). Seen from the back. Wood; overall height of figure, 133.3 cm. Golden Hall, Horyu-ji. (See also Figure 71.)*

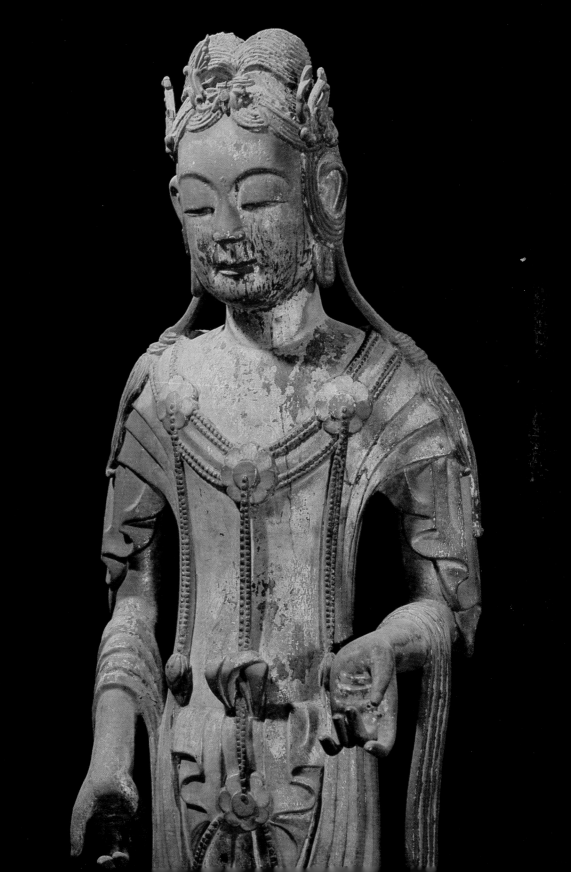

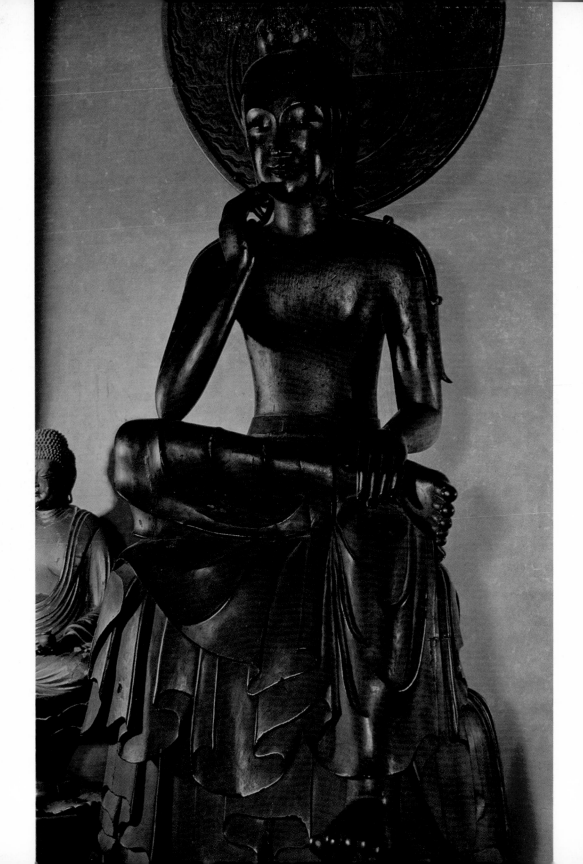

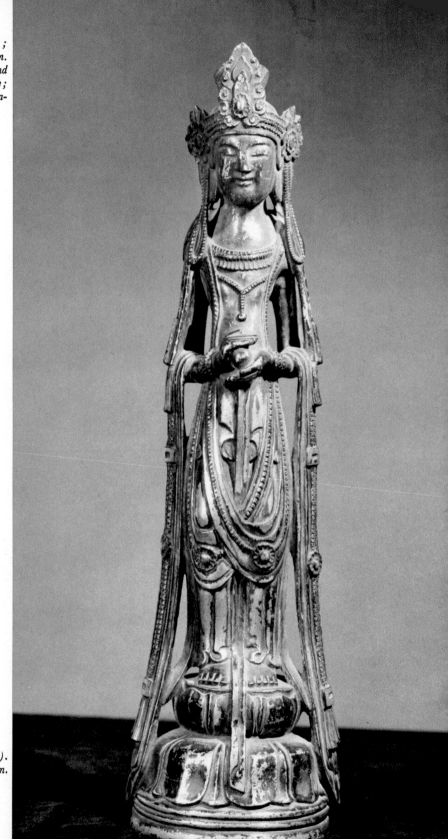

63. Left: Shingai Kannon (591); bronze; overall height, 34.8 cm. Right: Kannon Bodhisattva (second half of seventh century); bronze; height of figure, 26.6 cm. Tokyo National Museum.

64. Kannon Bodhisattva (c. 650). Bronze; overall height, 40.5 cm. Kanshin-ji, Osaka.

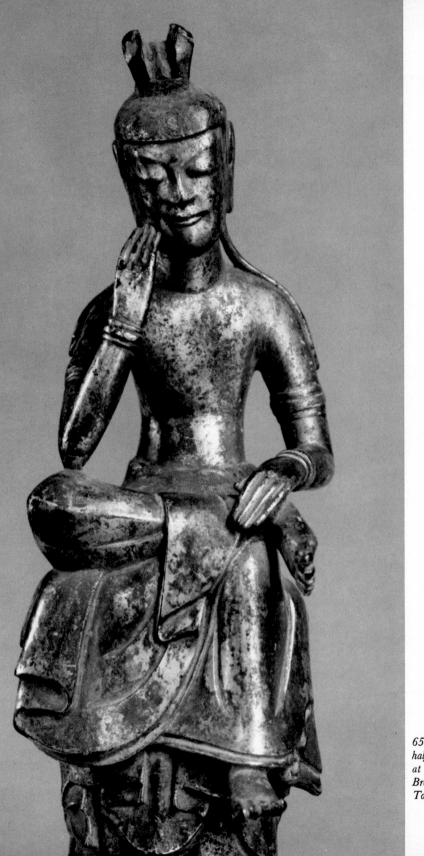

65. *Miroku Bodhisattva (second half of seventh century). Excavated at Nachi, Wakayama Prefecture. Bronze; overall height, 30 cm. Tokyo National Museum.*

Masterpieces of Asuka and Early Hakuho Sculpture

YUMEDONO KANNON In addition to the statues already discussed in connection with the early development of Japanese Buddhism and Buddhist art, there are a number of important Asuka-period masterworks at the Horyu-ji and in other temples and museums. Because of its immense artistic merit, the Kannon of the Yumedono in the East Precinct of the Horyu-ji is probably the most important of all these works.

Temple inventories from the mid-eighth century mention a life-size statue of Kannon in the Yumedono. But from earliest times, the statue in the Yumedono was regarded as so sacred that it was kept in white silk wrappings and shown to no one, not even to the monks of the temple. The American scholar Ernest Fenollosa, who did much in the nineteenth century to bring the value of ancient Japanese art to the attention of the Japanese themselves, was the first to unwrap and examine the statue. In the summer of 1884, during an inspection of the national treasures in the possession of the Horyu-ji, Fenollosa and one of his students, the famous Tenshin Okakura, had the statue uncovered for the first time in many centuries. Both men were amazed and enraptured by the beauty of the mystically smiling Kannon, the state of preservation of which was excellent, since it had never been exposed to the damaging elements.

Basically the statue is carved from a single block of camphor wood, though the lotus pedestal and the draperies falling from the arms are separate pieces. It is entirely covered with gold leaf on a lacquer base, and the hair and facial features are highlighted with black ink and color (Figs. 51, 52).

The style of the Yumedono Kannon, like that of the Shaka Triad in the Golden Hall, is faithful to late Northern Wei Chinese sculpture. Very tall for works of this kind (180 centimeters), the Kannon is flattish and completely frontal in orientation. The face is large and full, and the splendid filigreed bronze coronet is high and wide. A draped robe flows the full length of the figure from shoulders to feet. Finlike draperies arranged in left-right symmetry descend on both sides of the body to just below the feet. These draperies project outward in five sharp, rigid points from the elbows to the robe hem. Scroll-shaped locks of hair fall from the head and lie along the outer edges of the arms almost to the elbows. The hands, brought to breast height, hold a *mani* jewel surmounted by a flame-form ornament of bronze filigree. The left hand holds the jewel from the bottom, and the right hand partly covers it from the rear (Fig. 70).

The exquisite coronet (Fig. 67) is composed of a central peak and side wings, connected to form a half cylinder. The rounded lines of the delicate

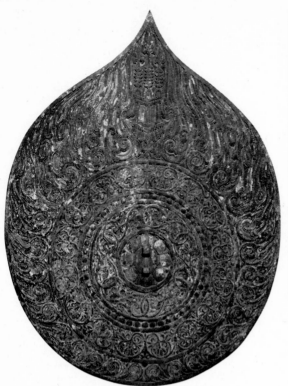

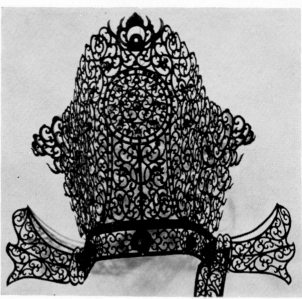

67. *Coronet of Yumedono Kannon (copy; original from first half of seventh century). Bronze. Yumedono, Horyu-ji. (See also Figure 69.)*

66. *Mandorla of Yumedono Kannon (first half of seventh century). Wood; height, 112 cm. Yume-dono, Horyu-ji. (See also Figure 69.)*

filigree are closer in nature to flame forms than to the vine-and-leaf motif seen in much Buddhist filigree. Five wheel-like discs decorate the band at the base of the coronet. From each of the central three of these discs project four scrolls. The flower form thus established is completed by means of blue glass beads. Other blue glass beads are dotted over the surface of the coronet and the ribbons descending from the sides. These ribbons, which undulate gently to the front and back, maintain balance with the similar curved lines of the draperies and robe (Fig. 69).

In contrast with the general tradition for statues of Bodhisattvas, the Yumedono Kannon wears very little ornament aside from the coronet and a plate-like necklace partly visible at the opening of the robe. But the shape of the coronet, the *mani* jewel at the breast, and the butterfly-shaped knot of the draperies tied just above the knees establish a distinctive vertical rhythm at the front.

Although the entire face, especially the eyes and the *byakugo* protrusion on the forehead (Figs. 52, 68), resembles those of the Shaka Triad in the Golden Hall and the Asuka Great Buddha, each statue creates a mood suited to the deity it represents. The Shaka in the triad is decorous, as befits a young Indian prince, as Shaka was before entering religious life. The Asuka Great Buddha displays majestic grandeur, while the Yumedono Kannon has a gentle, feminine quality. Like the attendant

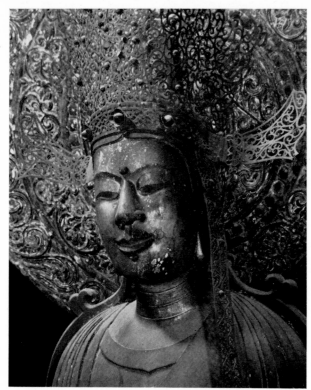

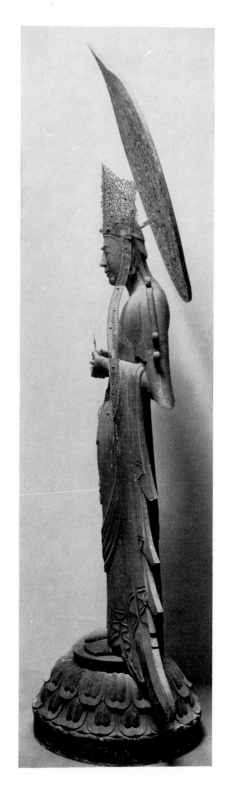

68, 69. Yumedono Kannon (first half of seventh century). Detail of head (above) and entire statue (right). Wood; height of figure, 179.9 cm. Yumedono, Horyu-ji. (See also Figures 51, 52.)

figures of the Shaka Triad, the Yumedono Kannon bears three folds on the neck, though in this case they are indicated by grooves only, with no fleshlike modeling. In fact, the general resemblance among the Kannon, the attendant figures, the Shaka, and the Asuka Great Buddha suggests that all of these works may have been made at roughly the same time and by workmen trained in the same general art methods.

The excellence of the design and carving make the mandorla (Fig. 66) of the Yumedono statue the finest of all Asuka works of the kind. In the center is a heavily modeled, single lotus blossom. This is surrounded by a ring of interlocking S curves. The ring next to this is decorated with round jewels, and

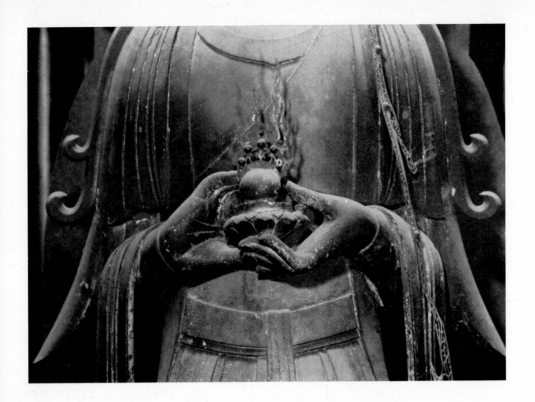

the next one with wavelike floral scrolls. This scroll pattern is similar to that found on the mandorla of the main image (Northern Wei) in the Pinyang cave at Lungmen (Fig. 177). The outermost ring of the mandorla of the Yumedono Kannon is decorated with fluidly graceful flames and is surmounted with a tower of the kind often seen in the hands of the Four Celestial Kings. Although some people argue that the unique beauty of the lines in the carving of this mandorla indicates that the statue is older than the Shaka Triad in the Golden Hall, the movement of the robe and draperies and the details of the face suggest that this is not the case. Another point connected with the dating of the statue involves the lotus-petal pedestal on which the figure stands. This pedestal (Fig. 69), made of a separate block of wood, closely resembles the pedestal of the Kudara Kannon (Fig. 82), which is of the later Hakuho period. Both works are gilded, which makes accurate estimations of age difficult. But I

agree with the theory that the pedestal of the Yumedono Kannon is probably a later addition.

In the Treasure Museum of the Horyu-ji is a small (56 centimeters) gilt-bronze statue of Kannon that in many respects resembles the Yumedono figure. This statue (Fig. 57), which has a massive and heavy appearance, holds a *mani* jewel in both hands at breast height. It has a high coronet and a flowing robe and draperies like those of the Yumedono Kannon; but its face, hands, and feet are large in proportion to the rest of the body. It stands in an imposing, straight-shouldered fashion, and the general impression it gives differs considerably from that of the statue in the Yumedono. The vigorous and massive lotus pedestal on which the small statue stands recalls the molding of the pedestal of the Shaka Triad in the Golden Hall.

In 1878, the Horyu-ji presented to the Imperial Household a collection of historical treasures numbering over three hundred items. After World War

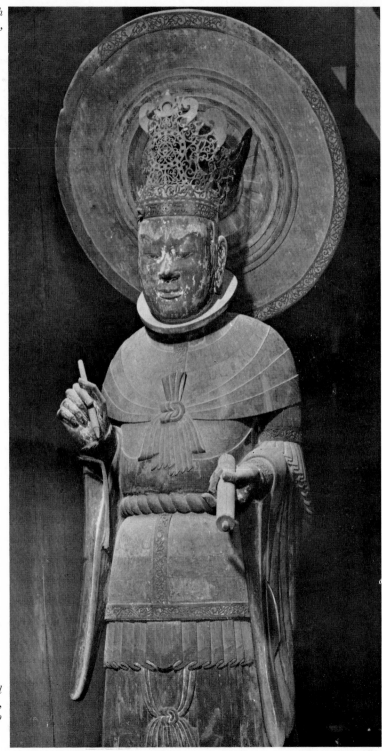

70. *Yumedono Kannon (first half of seventh century). Detail of hands. Wood. Yumedono, Horyu-ji. (See also Figure 51.)*

71. *Komoku Ten (one of the Four Celestial Kings; c. 650). Wood; height of figure, 133.3 cm. Golden Hall, Horyu-ji. (See also Figure 54.)*

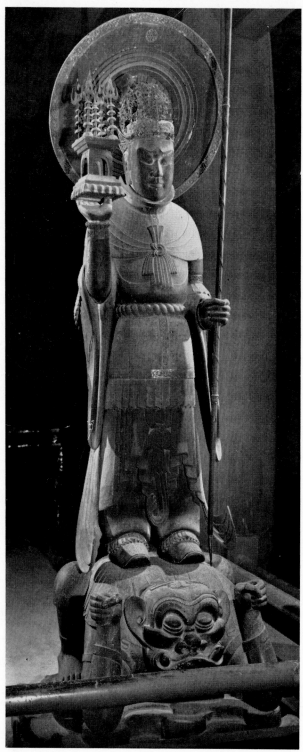

72. Tamon Ten (one of the Four Celestial Kings; c. 650). Wood; height of figure, 131.2 cm. Golden Hall, Horyu-ji. (See also Figure 73.)

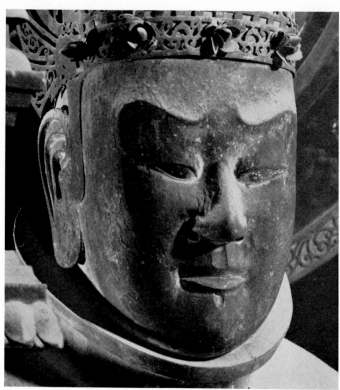

73. *Tamon Ten (one of the Four Celestial Kings; c. 650). Detail of head. Wood; height of entire figure, 131.2 cm. Golden Hall, Horyu-ji. (See also Figure 72.)*

II, the Gallery of Horyu-ji Treasures, a combined storehouse and exhibition hall, was built for these priceless pieces in the grounds of Tokyo National Museum. Among the treasures in the collection is a small Kannon that has a pedestal in a style comparable to that of the moldings of the Shaka pedestal. This small statue (34.8 centimeters) bears the sexagenary-cycle year *shingai*, which could be either 591 or 651. No documentary evidence exists to indicate which year is correct, but on the basis of the leanness and antique solemnity of the figure, I suspect that the older one is closer to the truth.

FOUR CELES-
TIAL KINGS

The Four Celestial Kings are guardian deities associated with the four cardinal points of the compass and were believed to have played a part in many important events in the life of Shaka. Representations of them acting as guardians of

Buddhism were placed at the four corners of the plots of ancient Indian stupas, or relic shrines. Like all deities represented in Buddhist iconography, they have symbolic colors and accessories, though in the case of the four kings these sometimes vary. In Japan the Four Celestial Kings are collectively called Shitenno. Individually they are Tamon Ten (Vaisravana)—also known as Bishamon Ten— guardian of the north; Zocho Ten, or Zojo Ten (Virudhaka), guardian of the south; Jikoku Ten (Dhrtarastra), guardian of the east; and Komoku Ten (Virupaksa), guardian of the west. At the Horyu-ji Golden Hall, as in many other temples, the Four Celestial Kings are placed at the four corners of the inner sanctuary.

The Horyu-ji statues (Figs. 53, 54, 71–73) are painted wood with some gold-leaf decoration. The coronets are of bronze filigree, as are the ornamental strips around the mandorlas and at the bottom

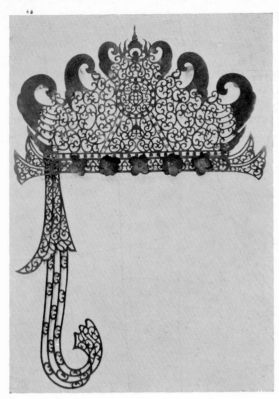

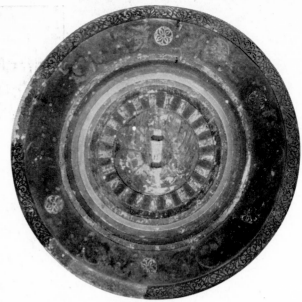

75. *Mandorla of Tamon Ten (c. 650). Wood. Golden Hall, Horyu-ji. (See also Figure 72.)*

74. *Coronet of one of the Four Celestial Kings (reconstruction; original c. 650). Bronze. Golden Hall, Horyu-ji.*

edges of the armor and the openings of the sleeves. Each of the figures surmounts a grotesque demon. This is a usual iconographic characteristic of these figures in their role of subduing wickedness; but in this case, the kings do not adopt the vigorous, conquering poses found in many similar statues. Instead, they stand serenely atop the demons, who, in spite of the ill-boding, weird expressions on their faces (Figs. 72, 76), crouch obligingly so that their backs form comfortable platforms.

Frontally oriented, the kings stand erect with eyes directed forward and slightly downward (Fig. 73). They wear large shoes, wide skirtlike garments called *hakama*, flowing upper garments, and armor breastplates bound at the waist with thick cords. The high, round collars are unusual. Except for Komoku Ten, all carry halberds. The pleats and folds of the skirts and sleeves (Fig. 54) are systematically arranged in a fashion that is both unusual and beautiful. Statues with similar costumes and similar blockish body shapes are to be found in the Northern Hsiangt'ang-shan caves in China. The Chinese sculpture in these caves was executed during the Northern Chou and Northern Ch'i periods (middle to late sixth century). Other comparable Chinese works date from the Sui period (late sixth to early seventh century).

The mandorlas behind the kings' heads (Fig. 75) center on a lotus pattern surrounded by a ring of carved radial lines and another of concentric circles. Beyond this section is a ring of wavelike floral scrolls and a decorative edging of bronze filigree. The last two elements suggest a similarity with the Yume-dono statue, and the resemblance does not stop here: the coronets (Fig. 74) of the kings are very much like that of the Kannon. They have central peaks and flanking wings joined by bands at the bottom. At the pinnacle of the central peak in each

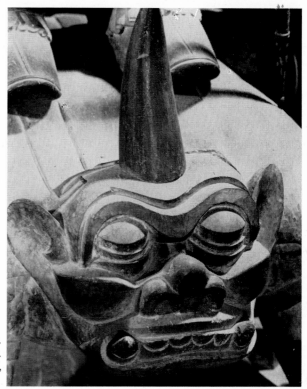

76. *Zocho Ten (one of the Four Celestial Kings; c. 650). Detail of demon on which the figure stands. Wood; height of demon, 38.5 cm. Golden Hall, Horyu-ji. (Compare Figure 72.)*

are a *mani* jewel and a crescent. The points of the wing sections spread somewhat widely, but in all other details they resemble the headdress of the Yumedono figure. The filigree pattern, which is neither floral nor flame form, suggests whirlpools. The bands of the coronets are composed of circles and stylized cloud motifs with a number of floral projections. The descending side ribbons undulate inward and outward as they fall to the shoulders. Though simpler than that of the Kannon, the kings' coronets all resemble it.

The faces of the kings, too, bear some resemblance to that of the Kannon, especially in the shape of the depression between the nose and the lips and the hollow between the lips and the chin. The expressions on the faces are an interesting combination of brows wrinkled as if in a scowl and lips that smile subtly. Though the tightly clenched hands are somewhat crude and monotonous, the

calm, composed appearance of the kings and the almost childlike faces of the demons are deeply impressive.

Dates for the statues are by no means definite, but there are some helpful inscriptions on the backs of the mandorlas of two of the statues. For instance, the inscription on that of the Tamon Ten figure says that Kusushi Tokuho and Tetsushi Maroko made the statue. A similar inscription on the back of the mandorla of the Komoku Ten says that Yamaguchi Oguchi no Atae and Tsugi no Komaro made it. It is known that Yamaguchi Oguchi no Atae was commissioned to make a set of one thousand Buddhas in the year 650. It may be that the Celestial Kings were made at about the same time. The fact that the statues are wooden and have bronze filigree ornaments leads one to believe that they may have been made as a group with the Yumedono Kannon. If this is not the case, the

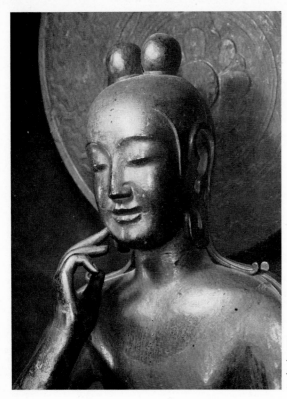

77. *Miroku Bodhisattva (second half of seventh century). Wood; height of entire statue (see Figure 59), 133 cm. Chugu-ji, Nara.*

Yumedono Kannon was probably produced at some date between those of the Shaka Triad and the Four Celestial Kings.

STATUES OF MIROKU MEDITATING

A further important group of Asuka-period sculptural masterpieces consists of several Bodhisattva figures with one foot resting on the knee of the other leg—the so-called half-lotus (*hanka;* literally, "half-locked") meditating position—and with one hand raised to the chin. The most famous of these statues is certainly the beautiful Miroku (Maitreya) of the Chugu-ji nunnery, adjoining the East Precinct.

The Chugu-ji (see page 10 and foldout plan facing page 24) was once the palace of Empress Hashihito, Prince Shotoku's mother. At her death, it was converted into a temple. Originally it stood about three hundred meters east of its present site,

to which it was moved in the Muromachi period (1336–1568), when it became part of the Horyu-ji. The only image remaining from the older Chugu-ji is the one known as the Miroku Bosatsu (Bodhisattva; Figs. 59, 77). Though today widely known by this name, it has not always been clear exactly which Buddhist deity the statue is supposed to represent. At one time it was thought to be the Nyoirin Kannon, but an inscription on a meditating statue at the Yachu-ji (Osaka; Fig. 62) and the name Miroku applied to the two similar statues at the Koryu-ji (Kyoto; Figs. 78, 79, 171) have led to the conclusion that the Chugu-ji figure, too, probably represents Miroku, the Buddha of the Future.

The Chugu-ji Miroku is made entirely of camphor wood, though the head and trunk, legs below the knees, and arms are separate pieces. The pedestal is not of one block—the cylindrical part

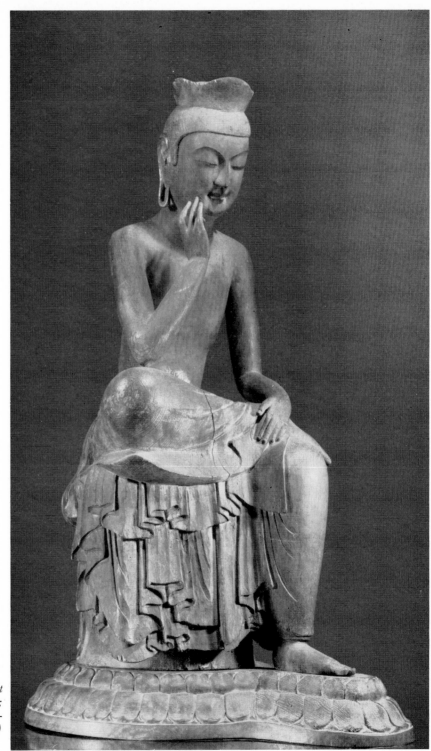

78. *Miroku Bodhisattva (first half of seventh century). Wood; height of figure, 123.5 cm. Koryu-ji, Kyoto. (See also Figure 171.)*

and the lotus pedestal are separate. Although the statue was once colored, the pigment has all peeled off. Today it is finished with plain lacquer. In comparison with the statue itself the upper pedestal is large, and the lotus pedestal is still larger, but these two parts stabilize the composition. At present, the statue lacks coronet, chest ornaments, and bracelets. Like a statue of Miroku (Fig. 65) excavated at Nachi in Wakayama Prefecture, the Chugu-ji Miroku has a headdress consisting of two globe-shaped chignons. The upper body is naked. The right arm is sharply bent, and the fingers of the right hand are brought to the chin in a position characteristic of the meditating pose. The side locks of the hair descend in symmetrical lines to the shoulders, where they form scroll-like curves. The refined and lovely face is roundish. The left leg, largely concealed by the draperies of the skirts, hangs straight down. But the right leg is bent and the right foot is placed on the left knee in the half-lotus position that is another characteristic of this type of statue. The skirt descends to the lotus pedestal and merges with the folds of the drapery enveloping the platform on which the statue sits. The folds of both are bold and beautiful. Although the draperies resemble those of the Shaka Triad in the Horyu-ji Golden Hall, the lines are more vertical and quieter. The fact that the carving of the draperies is deeper than that in the Kudara Kannon (Figs. 56, 82) suggests that this Miroku is closer in date to the Yumedono Kannon.

Unlike the painted mandorla of the Kudara Kannon (Figs. 55, 84), that of the Chugu-ji Miroku is carved. This too points to the greater age of the style of the latter. The outer section of the mandorla is ornamented with flame forms, the next with vine-and-leaf scrolls, the next two with concentric circles and radial lines, and the innermost with a rich and vigorously executed lotus (Figs. 59, 77). The small Buddha figures in the outer flame-form section are in low relief. In fact they are no more than outlines and flat surfaces, a style that seems to lie somewhere between that of sculpture and painting.

Two Miroku statues comparable to the Chugu-ji Miroku are owned by the Koryu-ji, Kyoto. They are distinguished from each other by the head-dresses: one is called the Crowned Miroku (Figs. 78, 171), and the other the Miroku of the Ornamental Headdress (Fig. 79). The Crowned Miroku is carved from one piece of red pine. The Miroku of the Ornamental Headdress is made of camphor. There is a record that in 623 a statue presented by the Korean kingdom of Silla was enshrined at the Koryu-ji. If this figure was either of the two Miroku statues at the Koryu-ji, it would probably have been the Crowned Miroku made of pine, since Japanese statues are rarely made of this wood. Although statues of this kind occur only in Japanese art of the Hakuho period (646–710), a small (90 centimeters) bronze statue of a similar kind in the Toksu Palace Museum in Seoul is dated around 600 (Fig. 192).

The fact that the Miroku of the Ornamental Headdress has this name does not necessarily mean that it did not once have a crown as well. It may have had necklaces and other jewels too; but if ever present, they have now been lost. The body, which is fleshier than that of the Chugu-ji Miroku, leans forward. The head is inclined, so much so that the figure would seem to be unsuitable as an object of worship. The long earlobes are pierced, forming rings. Because the eyebrows, eyes, and lips are long, and the mouth is closed in a sorrowful expression, the statue is sometimes called the Weeping Miroku. The folds of the full skirt fall to the lotus pedestal. There are draperies on the shoulders, made of cowhide. The statue was made in the Hakuho period.

One of the treasures donated to the Imperial Household by the Horyu-ji and now in the Tokyo National Museum is a slender bronze statue with a three-section coronet and wavy hair falling to the shoulders (Fig. 61). An inscription on the square-sectioned platform suggests that perhaps the statue was not imported from abroad. The treatment of the pedestal is unusual for Japanese work, but has counterparts in Korean sculpture (Fig. 191). The inscription gives the information that the statue was made in the year *heiin* in the Chinese sexagenary cycle, but this is difficult to pin down. The designati n *heiin* occurred in 606 and again in 666. There is no definite way of knowing which is the right year

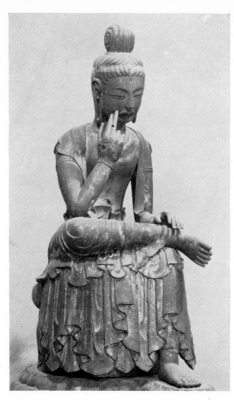

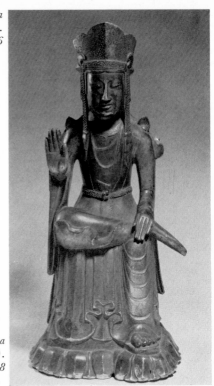

79 (left). Miroku Bodhisattva (second half of seventh century). Wood; height of figure, 100.6 cm. Koryu-ji, Kyoto.

80 (right). Miroku Bodhisattva (first half of seventh century). Bronze; height of figure, 41.8 cm. Tokyo National Museum.

for this work, but comparison with the Yachu-ji Miroku provides some evidence.

The Miroku now kept in the Yachu-ji in Osaka (Fig. 62) was originally commissioned by a group of a hundred and eighteen donors who were devout worshipers at a temple called Kashiwa-dera. Like the Miroku of Figure 61, it is known to have been made in the year *heiin*. But the considerable technical refinement of the Yachu-ji figure, as compared with the relatively primitive statue in Tokyo National Museum, suggests that the two cannot have been made in the same period. Thus it seems reasonable to conclude that the more primitive work dates from the earlier *heiin* year (606), while the Yachu-ji figure is from the later *heiin* year (666). The Yachu-ji Miroku is only 31 centimeters tall, but the platform on which it sits is large, and the draperies are rich. These two elements give the figure stability. The somewhat large and feminine

face is turned slightly downward, and the naked upper body has a childish appearance. The platform is octagonal in section and is decorated with lotus moldings. This is unusual. The lotus petals are decorated with linear engravings of cloud forms. The skirt decoration consists of bands of a flowerlike motif and, at the hems, of a motif resembling strung pearls.

One last statue in the Imperial Household Collection deserves special notice. This is the Miroku shown in Figure 80. The costume and coronet of this statue are very much like those of the Yumedono-style Kannon in the Horyu-ji Treasure Museum (Fig. 57). The face has an air of propriety. The hair and the bands of the coronet flow over the shoulders, which bear *mani* jewels. The right foot is raised to the left knee. Instead of being raised to the chin, as is characteristic of Miroku statues, the right hand is lifted to breast height and is in the reassurance

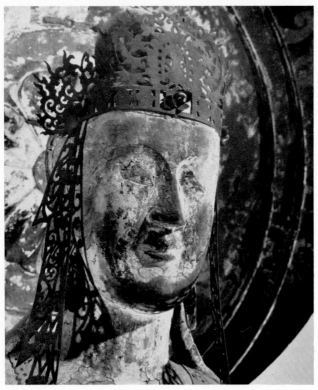

81. *Kudara Kannon (second half of seventh century). Detail of head. Wood; height of entire figure (see Figure 82), 209.4 cm. Treasure Museum, Horyu-ji. (See also Figure 55.)*

mudra (*semui no in*). The systematically arranged folds of the skirt fall to the lotus pedestal. The style suggests that this statue was probably made at about the same time as the Yumedono-type bronze Kannon of Figure 57—that is, in the late Asuka period (early seventh century).

KUDARA KANNON In addition to the Yume-dono statue, the Horyu-ji possesses another famous and noteworthy figure of the Bodhisattva Kannon. This is the so-called Kudara (Paekche) Kannon kept in a glass case in a special room of the Treasure Museum (Figs. 55, 56, 81, 82). The materials—camphor for the statue itself and cypress for the platform and the phial the statue holds—clearly indicate that the work was made in Japan. Still, the lines of the tall body, the curves of the draperies, and the elusively sorrowful expression of the face so strongly suggest foreign

influences that it is difficult to abandon the now firmly entrenched name of Kudara Kannon. Although temple tradition claims that the statue represents Kokuzo (Akasagarbha), there is nothing to prove this identification. In fact, since there is a small Buddha figure in the coronet, it is likely that the statue is of Kannon, who is usually represented with a small figure of Amida (Amitabha) in his headdress. Documentary evidence indicates that the statue was moved to the Horyu-ji in the Kamakura period (1185–1336) or later. Facing forward, the statue rests on a lotus pedestal. The small, almond-shaped eyes are directed to the front. The right hand is extended horizontally at waist level, and the left hand lightly holds a long-necked phial (Fig. 56). The coronet and necklace are of filigreed bronze (Fig. 83). The central section of the coronet is composed of floral-scroll patterns and the Buddha image. The side wings are decorated with flame

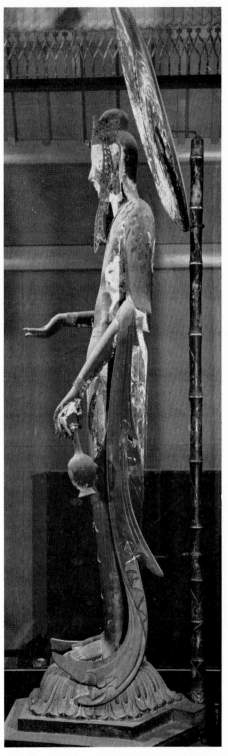

forms, and the head band with floral motifs. A
distinctive wave pattern is employed in the ribbons
descending from the coronet band. In comparison
with the designs of the coronets of the Yumedono
Kannon and the Four Celestial Kings, this one
seems less generous in mood. The design lacks
expansiveness, though this may be only the result
of the lowness of the coronet itself or of the great
height of the statue. Nevertheless, in point of
excellence, it must give way to the coronets of the
Yumedono Kannon and the Celestial Kings.

Ordinarily, when half of the chest of a Buddha or
Bodhisattva statue is bared, the garment descends
from the left shoulder to the right side of the trunk;
but in the Kudara Kannon this direction is re-
versed. The descending locks of hair seem to cling
closely to the body as if they were no more than
ripples of water. For this reason they lack the
rigidity of the hair of the Yumedono Kannon. The

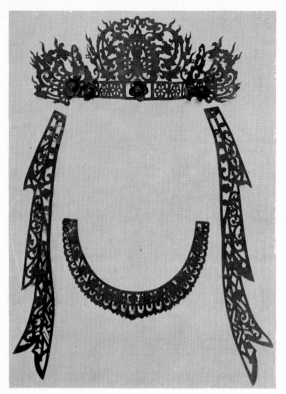

long draperies hanging from the elbows curve first to the rear and then forward. Seen from the front, they seem to be no more than thin boards. The eyes and nose are small and gentle in appearance, and the headdress sports a large chignon. In comparison with the severity of late Asuka pieces, the Kudara Kannon manifests more of the grace and elegance seen in the Four Celestial Kings and the Chugu-ji Miroku.

To conceal the sharp chisel marks in the wood, the statue itself was covered first with a base layer of something like dry lacquer. On top of this is a coat of Chinese white and a finish in paint of several colors. Seen from either the front or the side, the long figure has a facile, unaccented rhythm redolent of the mood of a utopian realm. Most of the mandorla (Fig. 84) is not carved, but painted. The outer section is covered with painted flame forms. The next ring is filled with a jewel design of

a kind often encountered in Chinese Buddhist art of the Sui period (589–618). The ring next to this is filled with a belt of cloud scrolls like those in the mandorla behind the Amida statue in Lady Tachibana's Shrine (Fig. 115). Next are decorations composed of radial lines and concentric circles. The innermost ornament, a single lotus blossom, is the only carved part of the mandorla. The design of the mandorla suggests that the work is newer than the Yumedono Kannon and the Four Celestial Kings. In all likelihood, it is contemporary with Lady Tachibana's Shrine, which dates from the middle of the Hakuho period. The design of the lotus pedestal reinforces this judgment.

HORIN-JI KANNON The statue of Kannon in Horin-ji temple in Nara (Figs. 85, 194) presents some interesting stylistic difficulties. Although it is called Kokuzo (Akasagar-

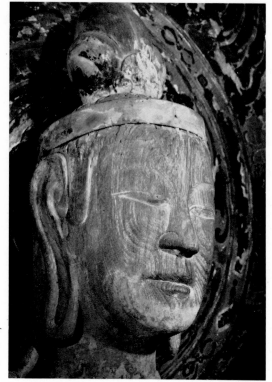

83 (opposite page, left). Coronet and necklace of Kudara Kannon (wooden copies; originals of filigreed bronze from second half of seventh century). Treasure Museum, Horyu-ji. (See also Figure 55.)

84 (opposite page, right). Mandorla of Kudara Kannon (second half of seventh century). Wood; height, 113.3 cm. Treasure Museum, Horyu-ji. (See also Figures 55, 82.)

85. Kannon Bodhisattva (second half of seventh century). Detail of head. Wood; height of entire figure (see Figure 194), 179.5 cm. Horin-ji, Nara.

bha Bodhisattva), the hand positions and the flask the statue holds clearly indicate that it is a representation of Kannon similar in some respects to the Kudara Kannon. The trunk of the body, however, is shorter and thicker than that of the Kudara figure. The mandorla is an addition of later times. The coronet has been lost, but the figure has a large ornamental headdress. The face is somewhat full, and the smile found on older statues is no longer present. The eyelids form slightly wavy lines. Large loop earlobes similar to the ones in this statue may be seen in such Hakuho works as the Six Bodhisattvas (Figs. 88, 89), the Yumetagai Kannon (Fig. 124), the Buddha head from Yamada-dera (Fig. 118), and the main Yakushi image at Yakushi-ji, Nara. The side locks flow over the shoulders like those of the Kudara Kannon. The transition between neck and trunk is smoother than is often seen in Asuka-style statues. The hair on the top of the

head is heaped high and tied in a chignon. The lines of the draperies, which have broken with the tradition of symmetry of older works, are free and gentle. This characteristic is especially noticeable in the knot in the center of the lower part of the skirt. These departures from established tradition suggest that the statue was made in the Hakuho period, although there is no way of knowing the date it was made. Nevertheless, the style of the lotus pedestal on which the figure stands seems to belong to the later Hakuho rather than the Asuka period.

HORIN-JI YAKUSHI AND THE SIX BODHISATTVAS

HORIN-JI YAKUSHI. The wooden statue of Yakushi (the Healing Buddha; Figs. 60, 86, 87), which is the main image of the Horin-ji, follows the tradition of the Shaka Triad of the Horyu-ji Golden Hall, though the heavy double pedestal on which it sits is

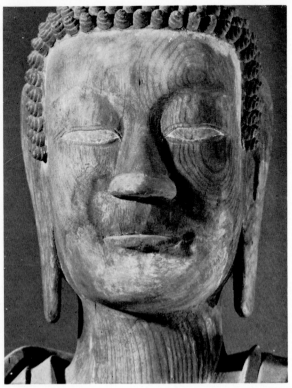

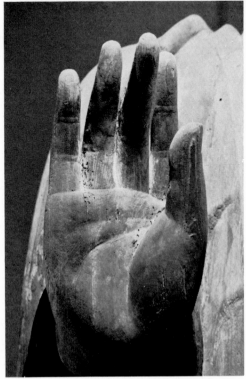

86. Yakushi Buddha (second half of seventh century). Detail of head. Wood; height of entire figure (see Figure 60), 105 cm. Horin-ji, Nara.

87. Yakushi Buddha (second half of seventh century). Detail of right hand. Wood; height of entire figure (see Figure 60), 105 cm. Horin-ji, Nara.

entirely different from that of the older work. The upper garment falls from the shoulders in the usual fashion, but the line of the right collar is almost perfectly vertical. The folds are generous. The length of the face suggests similarities with the angel musicians on the canopies in the inner sanctuary of the Horyu-ji Golden Hall (Figs. 8, 112). It may be that these small figures and the Horin-ji Yakushi are contemporaneous. The close resemblance between the face and garments of the Yakushi and those of the Horin-ji Kannon Bodhisattva (Fig. 85) leads me to believe that both were made in the late Hakuho period.

SIX BODHISATTVAS (HORYU-JI). As this group originally had eight figures, Eight Bodhisattvas would be a more apt name (Figs. 58, 88, 89). Temple tradition identifies the statues as representing the following Bodhisattvas: Nikko, the sun Bodhisattva; Gakko, the moon Bodhisattva; Kannon; Seishi (Mahasthamaprapta); Fugen (Samantabhadra); and Monju (Manjusri). However, only the figures of Kannon and Seishi have distinctive characteristics. Still, since there are slight differences among the six and since they seem to form pairs, some specialists argue that they were originally attendants for a group of Buddhas of the Four Cardinal Points. This is an argument that cannot be dismissed out of hand.

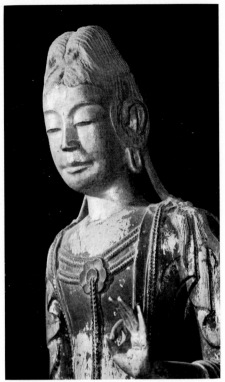

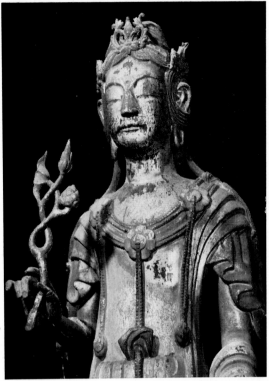

88. *Detail of one of the Six Bodhisattvas (second half of seventh century). Wood. Treasure Museum, Horyu-ji. (See also Figure 58.)*

89. *Detail of one of the Six Bodhisattvas (second half of seventh century). Wood. Treasure Museum, Horyu-ji. (See also Figure 58.)*

Each statue, including its pedestal, is carved from a single piece of camphor wood. They are partly coated—especially in the region of the head—with something like dry lacquer, and their surfaces are covered with lacquer and gold leaf. Although they are all frontally oriented, their stances are not rigid. The outward thrust of the bellies—apparent when the statues are seen from the side—is a tradition carried over from earlier sculpture, although the Bodhisattva figures have none of the flatness characteristic of Asuka-period work. In fact, they are marked by a gentle roundness of form and childlike facial expressions. The postures, too, are gentle. The abbreviation of the coronets and the treatment of the large ornamental headdresses are realistic touches that increase the natural appearance. In comparison with the severe majesty of Asuka statues, these figures manifest attributes of mercy. A feeling of kindliness is apparent in the natural way in which the splendid draperies and jewels are treated. These traits make the figures approachable and recall the sculpture of Ch'i, Chou, and Sui Chinese work and the Japanese sculpture of the late Hakuho period. Since there are similar statues in bronze among the Horyu-ji treasures at the Tokyo National Museum, the styles represented in these figures may have enjoyed wide popularity when this group was made.

The Later Hakuho Period: Reconstruction of the Horyu-ji

IN EARLY JAPANESE history, squabbles and wars over imperial successions were almost the accepted course of events. When Prince Shotoku died in 622 he left a son, Yamashiro no Oe, who, as far as blood relations were concerned, had a perfect right to expect to become emperor. As I have already said, the head of the Soga clan, Umako, seized the right to nominate the emperor of his choice when he elevated his niece to the dignity in 592. At the death of Empress Suiko in 628, Umako's son and successor, Soga no Emishi, followed in his father's footsteps by raising his own candidate to the throne and setting aside Yamashiro no Oe. The Soga repeated this slight to the prince on the death of this ruler, too. Throughout the period, Emishi and his son Iruka put on increasingly grand airs, acting as if they had a right to the immense powers they had seized. Soga no Iruka burned Shotoku's Ikaruga Palace to the ground in 643 and captured Yamashiro no Oe, who had long been one of the main obstacles in the path to absolute Soga power. Yamashiro no Oe and his entire family were either killed or forced to commit suicide. And with this tragedy, the line of Prince Shotoku became extinct. The sorrow of the people over the loss of so popular a family was

intensified when—probably in 670—the Wakakusa-dera, the temple founded by Shotoku, was destroyed by fire.

Rebuilding by a group of craftsmen from Paekche, first called together to build the Horin-ji and the Koryu-ji, started a decade later. The plan of the second temple—the Horyu-ji—differs in two major respects from that of its predecessor. First, the site of the Horyu-ji is oriented on a true north-south axis, whereas that of the Wakakusa-dera was twenty degrees off magnetic north. Second, the Horyu-ji has a different layout from the continental one seen in the Shitenno-ji and the Wakakusa-dera. In the older layout, the Inner Gate, five-story Pagoda, and Golden Hall were set out in a straight line. At the Horyu-ji, the Pagoda and the Golden Hall stand side by side on a line running east-west. I shall talk about this layout in more detail later, but at this point I should like to suggest a reason for the difference between the Wakakusa-dera and the Horyu-ji. Of course, what I say is supposition, because from the present vantage point in time, it is impossible to know what difficulties the designers of the temples faced in selecting and planning a site. It seems possible, however, that orienting the

90. *Central foundation stone of pagoda of Wakakusa-dera (first half of seventh century). Horyu-ji.*

Wakakusa-dera off north—when north-south orientation was important in Buddhist temples—may have been a consequence of the contemporary land-apportionment policies or of the proximity and shape of the site of Prince Shotoku's neighboring Ikaruga Palace. The different alignment of the buildings in the Horyu-ji may have evolved as a result of topography. The hill immediately north of the temple may have made it inconvenient to string all the buildings along a north-south line. In such a case, merely bringing the pagoda to the side of, instead of putting it in front of, the main hall would solve the problem.

The repairs on the major buildings of the Horyu-ji begun in 1945 entailed a certain amount of dismantling, which provided reliable information about the method of reconstruction of the temple. It seems likely that the details seen in the building of the Golden Hall are the oldest in the compound in terms of style. Furthermore, there is a considerable gap in time between the building of the Golden Hall and that of the Inner Gate and Pagoda.

Records reveal the interesting fact that economic assistance afforded the temple by Emperor Kotoku (r. 645–54) was stopped in 680 by Emperor Temmu. Because the imperial house was willing to cut funds back in this way, it is entirely likely that the major construction work of the Golden Hall—though not work on the murals and clay statues—was complete at this time. Work on the project got under way again in 691 and, judging from the contributions made to the temple by the Imperial Household, was probably finished two years later. In other words, by 693, the Golden Hall, Pagoda, and Inner Gate were probably completed. The fact that the Horyu-ji Pagoda looks older in style than the three-story pagoda of the Hokki-ji, lying northeast of Horyu-ji and known to have been finished in 706, lends credence to this view. The reconstruction process, then, stretched out over a number of decades. It was more than twenty years after the fire that the major parts of the temple were rebuilt. Almost another decade was required to finish the murals in the main hall and the clay sculpture in the Pagoda and Inner Gate. But by 711, all of these buildings, the surrounding corridors, and without doubt the monks' quarters—among them, perhaps, a building on the site of the present Higashimuro (East Quarters)—were finished.

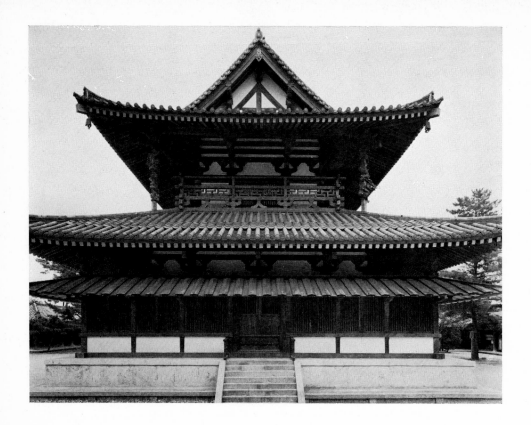

At one time, the style of the Horyu-ji was called the Asuka style, but it is closer to the truth to call it conservative Hakuho. Since very little is known about the architecture of the Asuka period, it is difficult to make pronouncements on the differences between the buildings of the two periods. But using the information obtained from excavations at the Shitenno-ji and the Hoko-ji and referring to the Tamamushi Shrine, one can see that these differences were of no great consequence. The Horyu-ji does indicate, however, a growing trend to develop native Japanese architectural styles, which, though subject to the influences of Ch'i, Sui, and T'ang China as passed on by craftsmen from all parts of the Korean Peninsula, nonetheless reveals a striving for independence.

Perhaps the sole striking stylistic difference between temple architecture of the Asuka and Hakuho periods derives from a purely Japanese innovation. This is the temple layout, about which I have already spoken. It was once thought that the old layout (the style found in the Shitenno-ji) and the new plan (that of the Horyu-ji) were probably used simultaneously in different buildings. It appears now, however, that the only buildings to use the new layout were those made during the Hakuho period, whereas older temples—Hoko-ji, Waka-kusa-dera, Yachu-ji—used the Shitenno-ji plan. An authority in this field, Jiro Murata, thinks that the Japanese style developed from the continental one in a fashion that is illustrated by the plans in Figure 16. The continental, or Shitenno-ji, plan was

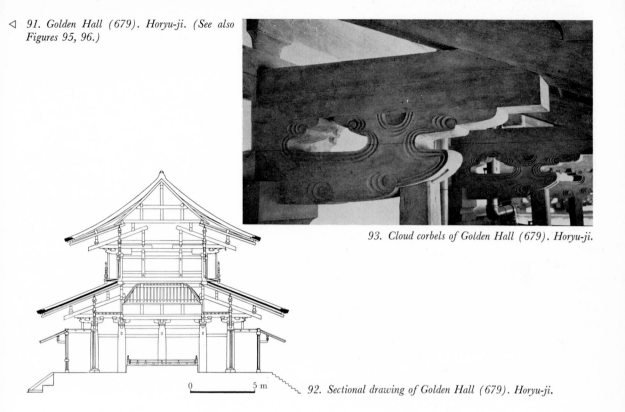

93. Cloud corbels of Golden Hall (679). Horyu-ji.

0 5 m

92. Sectional drawing of Golden Hall (679). Horyu-ji.

turned so that what had been the west side became the south side to produce what Murata calls the Tachibana-dera plan. Moving the inner gate from the east to the south created the Kawara-dera plan. Turning the main hall so that the length corresponds not to the north-south but to the east-west axis, resulted in the Koma-dera plan. And to produce the Horyu-ji plan from this, it was necessary only to interchange the positions of the main hall and the pagoda. The Shitenno-ji was an adaptation of layouts used in China and Korea, notably at the Northern Wei temple Yungning-ssu in Loyang and at Kunsuri temple in what was once Paekche in Korea. Though not all Hakuho temples used the new Japanese layout, it first became popular in the late Hakuho period, i.e., the late

seventh century and the first decade of the eighth century.

GOLDEN HALL The *shikorobuki* roofing style, found in the Tamamushi Shrine, is often considered a characteristic of Asuka architecture. As was said earlier (see page 46), this type of roof is distinguished by a distinct break between the surfaces of the sharply pitched upper and the more gently pitched lower sections. This break is not apparent in the exterior of the Horyu-ji Golden Hall roof, but the raftering, as seen in the sectional drawing (Fig. 92), is reminiscent of the *shikorobuki* style. The upper and lower sections of the roof employ separate sets of rafters, and triangular wooden elements are used at the points of juncture

94. *Detail of Golden Hall (679). Horyu-ji.* 95. *Detail of Golden Hall (679). Frontage, 18.52 m. Horyu-ji.* ▷

between the two sets. Exposed at the eaves, however, is one set of rafters, which are set parallel to each other throughout the structure without being radially placed at the corners. The use of two sets of rafters makes possible a more marked curvature of the roof, resulting in a strengthening of the feeling of lightness characteristic of Asuka architecture.

The eaves of the lower major roof project a considerable distance from the posts, although the effect is reduced by the ground-level aisle added at a later date. The eaves of the second-story roof extend 4.2 meters from the post centers. This has necessitated the installation of supplementary posts to help support the weight of the deep and heavy eaves. These posts are often criticized as eyesores, but it seems that they have been there since the earliest years of the building. The dragon carvings

that adorn the posts today are of uncertain date.

Although the Golden Hall appears to be two stories in height, only the first level is functional (Fig. 92). The handrail running around the second level is ornamented with panels in a modification of a gammadion pattern. These panels rest on ordinary brackets and braces called *kaerumata,* or frog legs.

The outer aisle around the main sanctuary has a coffered ceiling, and the main sanctuary itself has an elevated coffered ceiling. There are some features that characterize the building as somewhat old-fashioned for the time when it was built. The posts have marked entasis (Fig. 101), they are topped with bearing blocks and separate plates called *saraita,* and on these are brackets carved to form the so-called cloud corbels (Figs. 93, 94).

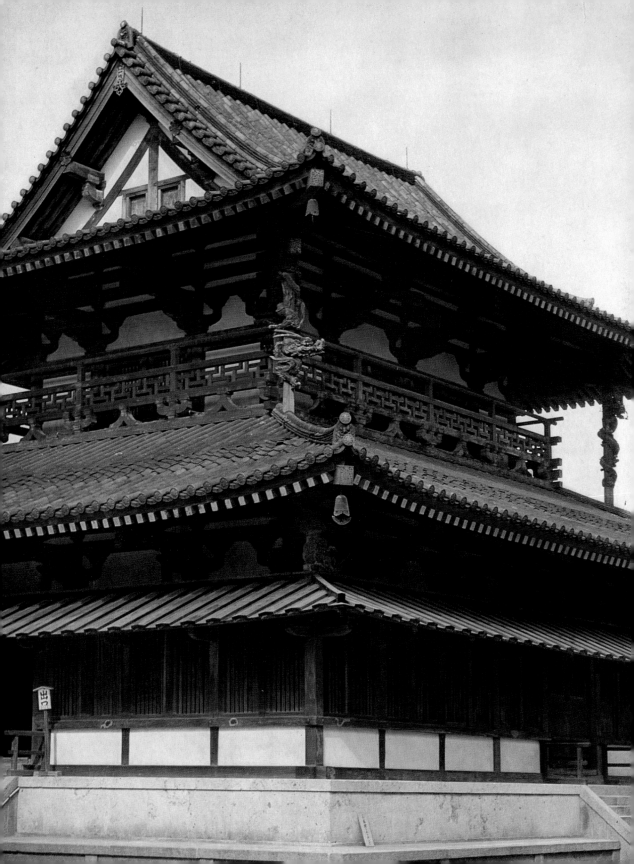

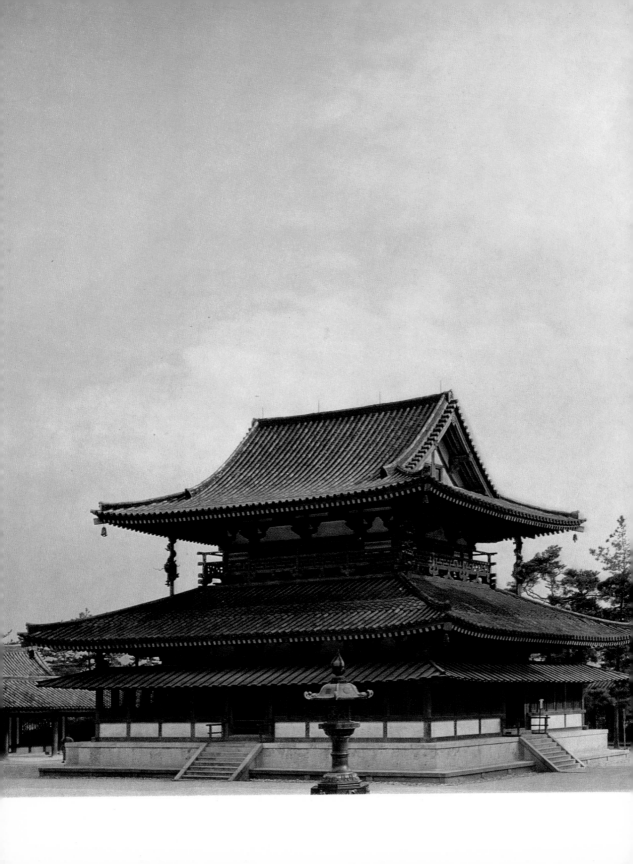

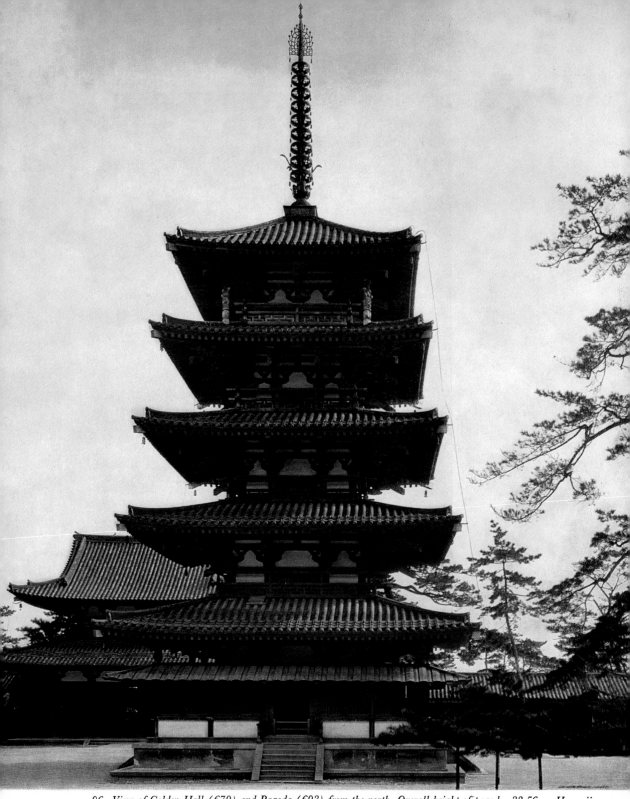

96. *View of Golden Hall (679) and Pagoda (693) from the north. Overall height of pagoda, 32.56 m. Horyu-ji.*

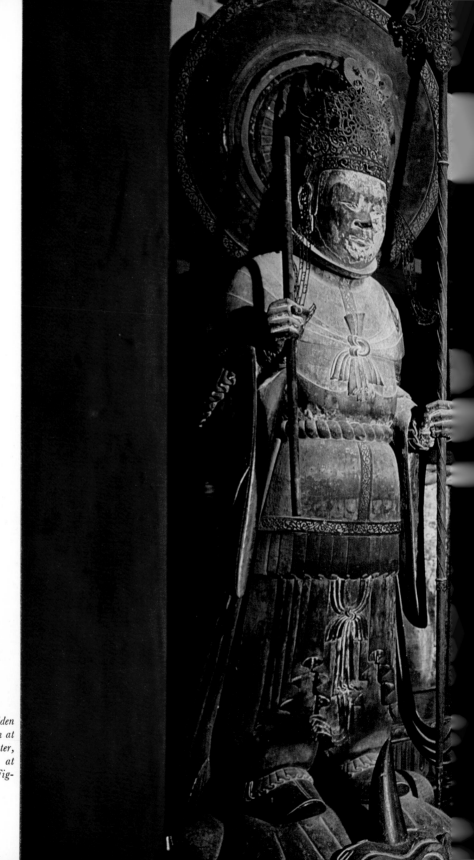

97. *Inner sanctuary of Golden Hall. Zocho Ten can be seen at left, the Shaka Triad at center, and the Yakushi Buddha at right. Horyu-ji. (See also Figure 17.)*

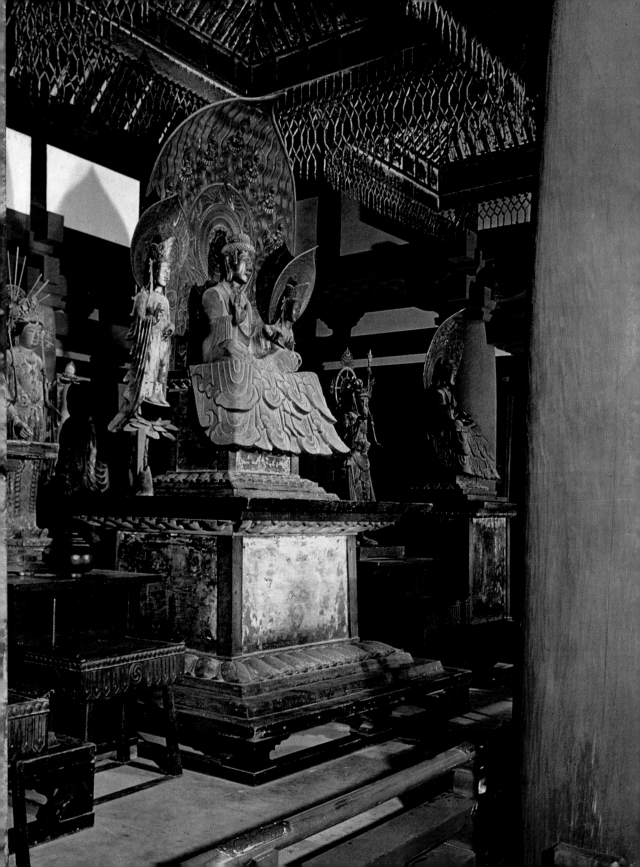

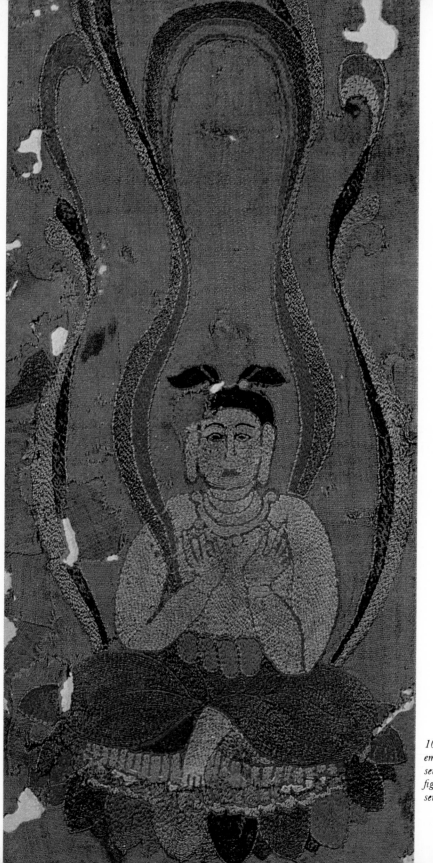

100. Flying angel. Detail of embroidered banner (second half of seventh century). Silk; height of figure, 10.5 cm. Fujita Art Museum, Osaka.

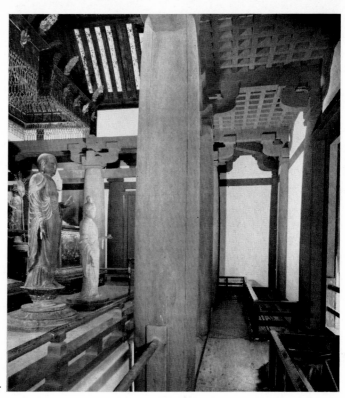

101. Interior of Golden Hall (679). Horyu-ji.

FIVE-STORY PAGODA In keeping with the Horyu-ji architectural tradition, the projection of the Pagoda eaves is deep. The roofs grow progressively smaller toward the top of the tower, and the lines of the composition are simple but lovely (Figs. 96, 102–4). The sets of brackets on the post capitals, under the eaves, and in the railings on each story are almost identical with similar members in the Golden Hall. Since the intercolumnar bays are narrow, it was probably difficult to achieve a sense of fullness in the appearance of the upper levels. Inside the Pagoda on the ground level are four inner posts called *shitembashira,* and the centerpost (*satchu*) projecting to the top of the tower.

Excavations conducted in 1926 showed that the centerpost of the Pagoda penetrated three meters into the ground to a foundation stone in which was a cavity for the relics. This structural system was of special interest to the scholarly world because it connected the Horyu-ji with temple traditions older than the Hakuho period. There is a record that at the building of the Hoko-ji pagoda the relics were first placed in the foundation stone. The stone was then put into the ground, and on the following day the main post was raised in place.

Further investigation in 1949 showed that the relics in the Pagoda were first placed in a small glass bottle, then in gold, silver, and bronze containers, and finally in a large jar. This multiple container was placed in a hole in the pagoda foundation. The hole was then covered with a

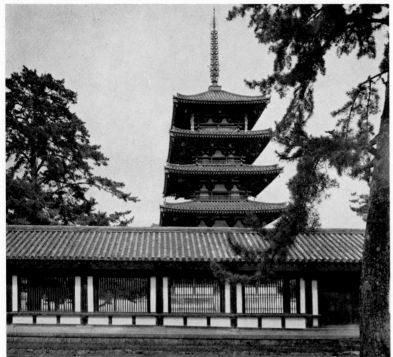

102. *View of Pagoda (693) beyond corridor. Horyu-ji.*

103. *Sectional drawing of Pagoda (693). Horyu-ji.*

bronze lid. In addition to the holy relics themselves, beads and a famous mirror with a repoussé design of hunters and vines were found in the foundation. This way of enshrining relics is reminiscent of Indian methods.

In the space between each pair of inner posts in the Pagoda is a grottolike niche housing clay sculpture. In the south bay is a representation of the paradise of the Bodhisattva Miroku; in the west bay, the Division of the Relics; in the north bay, the Nirvana (death) of the Buddha; and in the east bay, Yuima (Vimalakirti) and the Bodhisattva Monju (Manjusri; Figs. 138, 139). According to a record called *Ruki Shizaicho*, compiled in 747, these statues were completed in 711. The guardian

statues in the Inner Gate were finished at the same time, and the installation of these works marked the completion of the rebuilding of the Horyu-ji.

Comparisons of the architecture of the Pagoda and the Golden Hall suggest that the Golden Hall was the first to be built, followed by the Pagoda and Inner Gate, and then the corridors, the reconstruction being finally completed in 711 with the addition of the Golden Hall murals and the clay statuary of the Pagoda.

INNER GATE Though less grandiose than those that surround Chinese temples, the Inner Gate and corridors at the Horyu-ji are beautiful in a compact, quiet way. Passing through the

104. Detail of Pagoda bracketing (693). Horyu-ji.

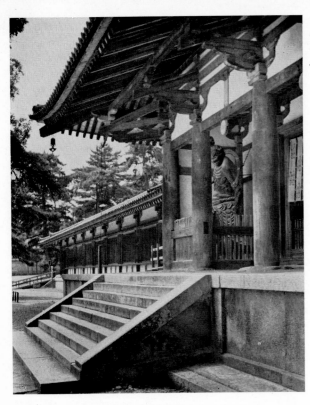

105. *View of Inner Gate (693), showing one of the Nio guardians. Part of the veranda corridor can be seen beyond the gate. West Precinct, Horyu-ji.*

106. *Inner Gate (693) from inside the* ▷ *main compound. Frontage, 11.88 m. Horyu-ji.*

gate and along the corridors, one enjoys surprisingly varied views of the Golden Hall and Pagoda. Oddly enough, the east half of the south corridor is one bay longer than the west half. (See foldout plan facing page 24.) This may result from the fact that the Golden Hall, which has a greater area than the Pagoda, is on the east side of the compound. But the length discrepancy is nonetheless odd for an architectural tradition that generally employs symmetry in form and placement. Perhaps this design attitude reveals the tolerant and free quality of ancient architecture. The inner sides of the corridors consist of rows of posts with characteristic entasis, though the bulge is less pronounced than in the posts of the Golden Hall. On the outer sides are low walls and

wide lattice windows. So-called rainbow beams connecting inner and outer posts are topped with an inverted-V member surmounted by the king post supporting the ridge pole. This simple structural system creates a very beautiful effect.

The plan of the Inner Gate diverges from the standard in that it is four bays wide and three bays deep, having two openings instead of the traditional one. A number of involved theories have been advanced to explain this unusual plan, but it may well be that the simple need for a separate approach for the Pagoda and another for the Golden Hall is the answer. In fact, precisely this explanation is suggested in a record called *Kokin Mokurokusho.*

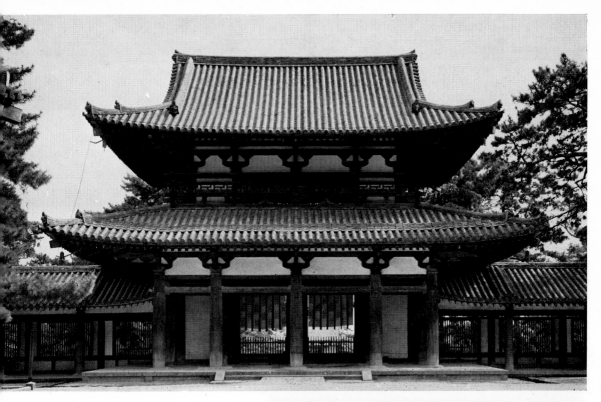

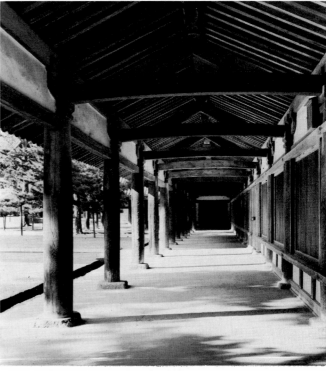

107. View along corridor (693). Horyu-ji.

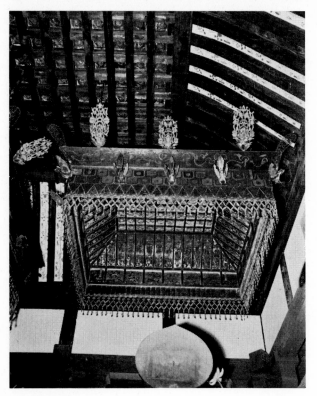

108. *Canopy (second half of seventh century). Golden Hall, Horyu-ji. (See also Figure 8.)*

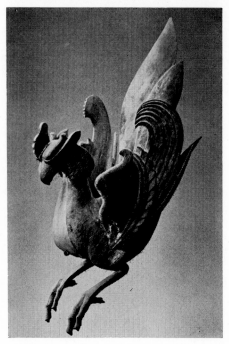

109. *Bird ornament of canopy (second half of seventh century). Wood; height, 30 cm. Golden Hall, Horyu-ji.*

INTERIOR OF THE GOLDEN HALL The molding on the stand of the double pedestal on which the Shaka Triad rests (Fig. 97) resembles that of the statue of Shingai Kannon (Fig. 63), dated 591. This suggests that the pedestal and the Shaka Triad were made at the same time. Possibly, if the cause of the disastrous fire of 670 was lightning, it may have spread from the Pagoda, which would be in danger during an electrical storm because of its height. In such a case, the monks would have had time to salvage this wooden pedestal from the Golden Hall before the flames reached it. The pedestal could conceivably be as old as the Shingai Kannon.

The inverted-box-shaped canopy over the Shaka Triad consists of wide side pieces topped with a flaring molding (Figs. 8, 108). The side pieces are ornamented with a fish-scale design and another pattern of triangles. The flaring border is decorated with floral scrolls. From the lower edge of the side pieces is suspended a network of glazed porcelain beads. The semicircular "strung pearls" pattern at the top of the side pieces is noteworthy because it was very popular in Sui China (589–618).

The interior of the canopy (Fig. 108) is coffered like the ceiling of the Golden Hall sanctuary itself. Flower motifs decorate the top sections of the coffering. The long, narrow sloping sections are decorated with what appear to be lotus flowers, and the bottom tier of panels carries scenes of distant

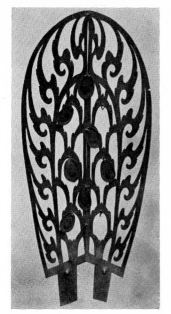
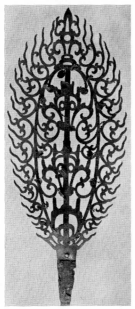

110, 111. Canopy ornaments (second half of seventh century). Bronze. Golden Hall, Horyu-ji.

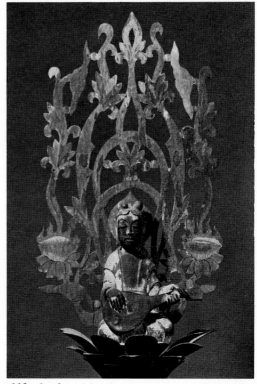

112. Angel musician (canopy ornament; second half of seventh century). Wood; height of figure, 17 cm. Golden Hall, Horyu-ji.

mountains. On the upper edge of the flaring molding at the top are small angel musicians seated on lotus pedestals. The angels' draperies swirl upward behind them (Fig. 112), as if they are descending from heaven. The elongated, full, childlike faces of the angels and their charming double chignons closely resemble those of the late-Hakuho Six Bodhisattvas (Figs. 88, 89) and the statue of Yakushi enshrined next to the Shaka Triad in the Golden Hall. Judging by this, these angels were possibly made for the Hakuho-period reconstruction of the temple, although there is nothing to prove this judgment. Between the angels and at the corners of the canopy molding are exquisite flame-form bronze filigree ornaments of two kinds (Figs. 110, 111). Below the brilliantly executed molding are bird figures possibly representing a kind of phoenix. With outstretched legs, spread wings, forward-thrusting breasts, and retracted heads, the birds have a somewhat menacing quality.

BUDDHIST SCULPTURE OF THE HAKUHO PERIOD

LADY TACHIBANA'S SHRINE. Old records inform us that the Horyu-ji Golden Hall possessed two shrines. One of these is the Tamamushi Shrine (Fig. 43) already discussed. The other is Lady Tachibana's Shrine (Fig. 114). The lady in question was Tachibana Michiyo (died 733), wife of the great political figure Fujiwara

113. *Lady Tachibana's Shrine (second half of seventh century). Detail of "Lotus Pond." Bronze. Treasure Museum, Horyu-ji. (See also Figure 137.)*

Fubito and mother of Empress Komyo. There is some doubt that the shrine bearing her name was in fact her property, but since the probable date of construction of the shrine corresponds with the lady's lifetime, the tradition that it was hers is difficult to abandon.

Unlike the Tamamushi Shrine, which is a model of a palace building, Lady Tachibana's Shrine is a box form resting on a pedestal that is somewhat small in proportion to the rest of the work. This size relationship in itself leads one to believe that the shrine is of the Hakuho period. The top section of the box form resembles the canopy of the Shaka Triad very closely. It is ornamented with the same fish-scale, triangle, and "strung pearls" patterns. Furthermore, the coffering inside the shrine is decorated with painted scenes of distant mountains,

floral scrolls, and lotus blossoms. The pedestal is like that of the Tamamushi Shrine, except that the molding is rounded and less sharply raised. The flat panels of the pedestal are decorated with pictures painted on a ground of Chinese white. The pictures represent Bodhisattvas making offerings, heavenly beings on lotus blossoms, and *arhats* (disciples of the Buddha) in mountain scenes. The borders of the pedestal are decorated with parabolic wave patterns the curves of which recall Sui and T'ang Chinese art.

In the boxlike main section is a bronze Amida Triad that is one of the most outstanding examples of Hakuho-period sculpture (Fig. 137). The figures rest on a bronze plate ornamented in low relief to look like a lotus pond (Fig. 113). Two shafts rising from the back edge of the plate support the screen

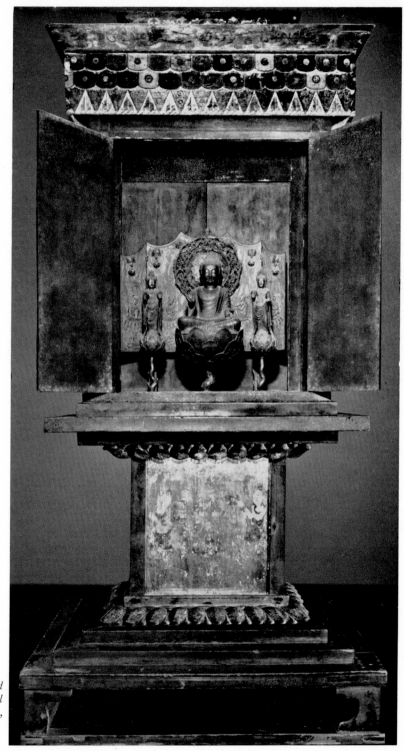

114. *Lady Tachibana's Shrine (second half of seventh century). Wood; overall height, 263.2 cm. Treasure Museum, Horyu-ji.*

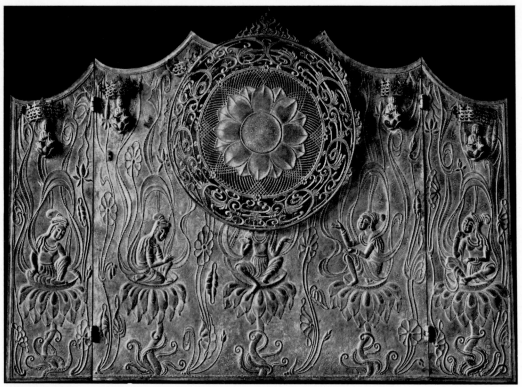

115. *Screen of Lady Tachibana's Shrine (second half of seventh century). Bronze; height, 53.3 cm. Treasure Museum, Horyu-ji. (See also Figures 114, 137.)*

behind the statues (Fig. 115). The figure of Amida rests on a half-open lotus blossom mounted on a spiral stalk rising from the lotus-pond plate. The attendant figures flanking Amida stand on two similar, though smaller, lotus flowers. Amida, seated with crossed legs, has half-closed eyes. His right hand is in the *semui* reassurance mudra and his left in the *yogan* wish-granting mudra. The fingers are not as rigid as in the Asuka Great Buddha. The head is large, the earlobes long, and the neck full. The appearance of the statue as a whole is lovely and gentle. The beautifully executed mandorla behind Amida's head consists of a lotus flower, radiating lines suggesting light, and gracefully curving cloud and floral-scroll forms.

Though all parts of the group are lovely, the low-relief screen behind the statues is outstanding.

Lotus stalks curving upward in undulating lines support blossoms of surprisingly stable appearance. On these flowers sit souls reborn in paradise, from whose postures and faces joy seems to emanate. The draperies of the figures, together with lotus leaves and stems, swirl toward the upper edge of the screen, where there are small Buddha figures seated on lotus pedestals. These figures suggest a doctrinal connection with similar small Buddhas on the mandorla of the statue of Yakushi in the Golden Hall, though the forms of the two sets of figures are different.

The attendant figures may be identified as Seishi (Mahasthamaprapta), whose coronet incorporates a holy flask, and Kannon, who, as is usually the case with this Bodhisattva, has a small figure of Amida in the coronet. The faces of the three figures,

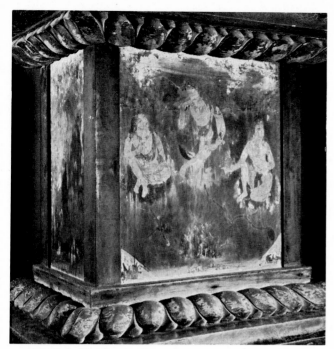

116. *Lady Tachibana's Shrine (second half of seventh century). Detail of base. Wood. Treasure Museum, Horyu-ji. (See also Figure 114.)*

117. *Detail of Bodhisattva from door panel of Lady Tachibana's Shrine. Wood. Treasure Museum, Horyu-ji.*

the generous lines of the garment of Amida, and the pliant ones of the draperies of the Bodhisattvas clearly indicate the hand of the same artist. The total composition, beautifully balanced, ranks with the finest works of the late Hakuho period.

Of the original eight leaves of doors attached to the four sides of the shrine, two have been lost. The four panels on the sides bear pictures of the Four Celestial Kings on the outside and of four Bodhisattvas on the inside. The left front leaf has been lost, but since the remaining right leaf has a painting of a guardian of the Buddhist scriptures (Kongo Rikishi) on the outside and a Buddha on the inside, it seems likely that similar pictures adorned the lost panel. Of the rear leaves, the right one has been lost, but there is an angel on the outer and a figure like a Bodhisattva (Fig. 117) on the inner surface of

the left leaf. It is probable that the lost leaf bore similar pictures. The scholar Terukazu Akiyama suggests that the paintings on the rear panels may have been representations of Bon Ten (Brahma) and Taishaku Ten (Indra). The important point to notice about these pictures is their stylistic divergence from Buddha and Bodhisattva iconography of the Hakuho period and their resemblance to the murals of the Golden Hall. The figures are shown with mature fullness of flesh, natural postures, and flowing garments. In these points they differ in style from the Amida Triad within the shrine and from the paintings on the panels of the pedestal. In order to explain this stylistic variety it is necessary to assume either that the art of painting changed more rapidly than architecture, crafts, and sculpture, or that the shrine and the statues were

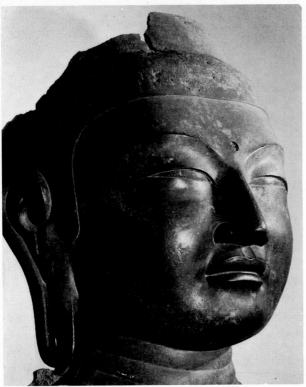

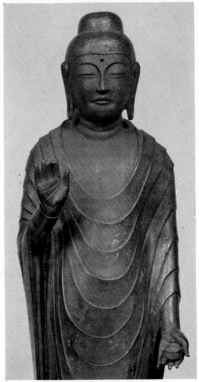

118. Head of Buddha from Yamada-dera (685). Bronze; height, 97.3 cm. Kofuku-ji, Nara.

119. Ko Yakushi (second half of seventh century). Bronze; height of figure, 73 cm. Shin Yakushi-ji, Nara.

completed first and the door paintings executed at some later date.

YAMADA-DERA BUDDHA. The Buddha head today housed in the museum of Kofuku-ji temple in Nara (Fig. 118) was once part of the main image of the lecture hall of another temple, called Yamada-dera. All but the head was destroyed in a fire at the Kofuku-ji. Although only the bronze remains, it is virtually certain that the statue was once covered with gold leaf. The Yamada-dera was commissioned by a member of the powerful Soga clan, Soga Kurayamada Ishikawamaro (died 649), but construction seems to have been delayed. The Buddha statue was not cast until 678, and the dedication ceremony was not held until 685. The

headdress lacks the multitude of tight curls often found on Buddha statues. The face is roundish and full, the eyes and brows are long, the thick lips are tightly closed, the cheeks and chin are full, and the long, pierced earlobes form loops like those frequently found in statues of Bodhisattvas. There are three folds in the thick neck. Characterized by these traits, more common in Bodhisattva figures, the head has a certain magnificent grandeur and lacks the childlike appearance of much sculpture of the Hakuho period.

KO YAKUSHI AND THE JINDAI-JI BUDDHA. The Ko Yakushi statue (Fig. 119) belonging to the Shin Yakushi-ji (Nara) and the seated Buddha (Fig. 120) of the Jindai-ji (Tokyo) are representative late

Hakuho works. The Ko Yakushi statue, which was stolen in 1943 and has not been recovered, has a round face, long, looped earlobes, and three folds in the neck. The raised lines of the brows merge with the lines of the nose. The narrow eyes and the mouth are long and horizontally placed. Both the Ko Yakushi and the seated Buddha of the Jindai-ji, like the Horyu-ji Yakushi, lack spiral curls on their heads. The folds of the garment covering the Ko Yakushi fall in concentric curves. The lines of the flesh under the garment are vaguely visible, and the chest is full. Because the figure—especially the hands—is somewhat stiff and rigid in comparison with the Amida figure in Lady Tachibana's Shrine, the statue may be assigned to an earlier part of the Hakuho period.

The rounded forms of the flesh of the seated Buddha of the Jindai-ji (Fig. 120) are more apparent than in the Ko Yakushi. Although the statue is generally said to represent Shaka, this is open to question. For instance, the seated posture would better suit statues of Miroku, and the left hand is held in a position suggesting that it might be holding something—perhaps the jar of medicine associated with the Healing Buddha, Yakushi. The lines of the drapery follow the undulations of the body forms from the chest to the abdomen. Although the expression of the hands is more tender and delicate, the feet are very much like those of the Ko Yakushi statue. The ornamental folds of the lower draperies hint at older styles. This may be due to the location of the statue. Because of the distance involved, new sculptural styles would have reached the Kanto area later than areas close to the capital. Thus this statue could date from as late as the beginning of the eighth century, in spite of its style.

GILT-BRONZE KANNON. Although the gilt-bronze Kannon now in the Horyu-ji Treasure Museum and a similar statue were formerly thought to be attendants of an Amida statue in the Horyu-ji Golden Hall, it has turned out that the other figure of the imagined pair is in fact a copy made during the Kamakura period (1185–1336). This Kannon (Fig. 121) stands on a large lotus pedestal. The chest is pulled in, in an attractive posture. The round, plump face is somewhat large, balancing the size of the lotus pedestal. The chignon sweeps back in two wing-shaped sections. The coronet is executed in a clear, clean fashion, and its slender side ribbons descend to the front of the chest. Long side locks flow along the upper edges of the shoulders. The abundant draperies and rich jewels are arranged in an orderly, natural fashion. The right hand holds a phial and the left a round jewel. Both hands are beautifully executed, as are the face and the exposed arms. Although the posture of the figure is clearly evident under the garment, no special attempt has been made to give the feeling of flesh. The clear, deep engraving of the lines of the figure suggests lingering older traditions, but everything below the coronet, including the draperies and the jewels, represents newer artistic trends. In other words, the statue represents a blending of the new Hakuho-period styles and older traditions. A number of similar statues are found among the art works in the Imperial Household Collection. Among them, one statue is so similar to this figure that the two might form a pair.

YUMETAGAI KANNON. Still another exquisite statue in the Horyu-ji Treasure Museum is the so-called Yumetagai, or Dream-changing, Kannon (Figs. 124, 136). The figure, which is 87 centimeters tall, stands with an air of dignity and strength. Though the round and childlike face resembles that of the Ko Yakushi at Shin Yakushi-ji (see page 112), the workmanship in the Yumetagai Kannon is immensely superior. The carefully arranged hair is tied in a large chignon. The coronet, consisting of three isolated plates, is quite large; but it lacks side ribbons, and the band connecting the plates is very slender. There are no side locks of hair flowing over the shoulders in the usual way. Rich jewels adorn the full-fleshed, thickish chest. Draperies falling from the shoulders cross the arms and intersect in a simple but effective way with the vertical lines of the skirt, the bottom of which is somewhat flat.

The name of the statue derives from the belief that worshiping this Kannon brings relief from nightmares. Although this is a popular tradition of comparatively recent times, the purity and beauty of the face of the statue do seem to promise

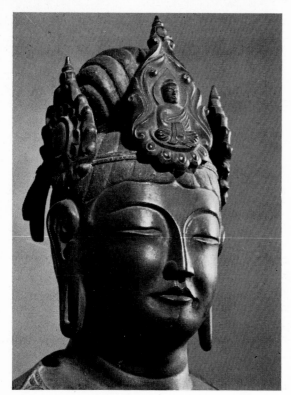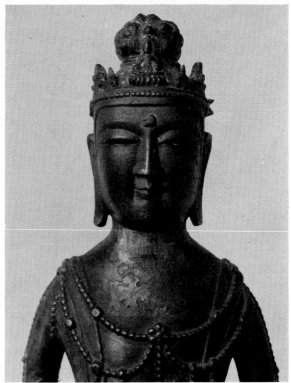

liberation not only from bad dreams, but from other kinds of perplexity as well. The supple fingers, especially those of the left hand, which holds a small jar, are very lovely. The creases on the chest and abdomen are unusual.

KAKURIN-JI KANNON. The Kannon statue at the Kakurin-ji in Hyogo Prefecture (Fig. 123), is comparable to the Yumetagai Kannon, though stylistically it is probably one step more advanced. The face of the figure, which is 83.2 centimeters tall, is charmingly childish and round. Throughout the statue, the details are more natural than in the Yumetagai Kannon. Long, horizontally oriented brows and eyes, and broad cheeks characterize the face. The side ribbons of the coronet and side locks of hair fall to the shoulders. The simple engraved lines of the three folds in the neck hark back to older traditions, though the slight sway of the hips, probably borrowed from Indian statues, is a characteristic of Chinese sculpture of the Sui and early T'ang (618–907) dynasties. There is nothing to assist in dating the work, but if it is Hakuho, its advanced style suggests that it must have been produced in the very last part of that period.

KANNON STATUES AT ICHIJO-JI AND GAKUEN-JI. The standing statue (96.5 centimeters) of Kannon today owned by the Ichijo-ji in Hyogo Prefecture (Fig. 125) dates from the late seventh century. The face is somewhat small. There are rich jeweled ornaments on the chest. The general style resembles that of Chinese sculpture of late Ch'i and Sui times (late sixth to early seventh century). The similar standing figure of Kannon at the Gakuen-ji, Shimane Prefecture, is 80.4 centimeters tall (Fig.

124 (opposite page, left). Yume-tagai (Dream-changing) Kannon (second half of seventh century). Detail of head. Bronze. Treasure Museum, Horyu-ji. (See also Figure 136.)

125 (opposite page, right). Kannon Bodhisattva (second half of second century). Bronze; height of entire figure, 96.5 cm. Ichijo-ji, Hyogo Prefecture.

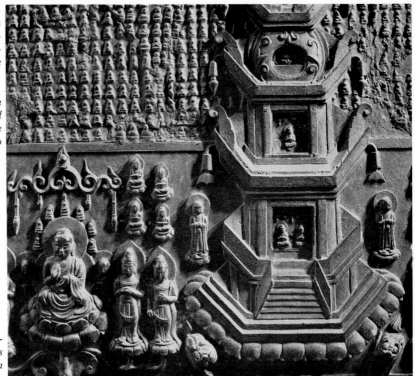

126. Bronze plaque of the "Thousand Buddhas" and a Precious Pagoda (686). Hase-dera, Nara Prefecture.

122). Frontally oriented, the statue is more rigid in appearance than the Ichijo-ji Kannon. The jewels on the chest, though less rich, cross to form an elaborate X pattern in front of the abdomen. The left hand—which once held a phial—and the fingers of both hands are delicately executed. An inscription on the lotus pedestal states that Waka-yamatobe no Omi Tokutari had the figure made in 692 for his mother. The style of the statue seems much older than this date.

HASE-DERA BRONZE PLAQUE. The period between 690 and 710, which saw the complete reconstruction of the Horyu-ji, was one of astounding change and development in Japanese Buddhist architecture, crafts, sculpture, and painting, largely owing to the influence of the mature T'ang culture. A variety of changes were occurring in such branches

of sculpture as bronze, wood, clay, and dry-lacquer statuary. The bronze plaque showing the "Thousand Buddhas" and a Precious Pagoda (Tahoto), owned by the Hase-dera temple in Nara Prefecture, was produced during this time of great industry and change. Fortunately, an inscription on the work makes it possible to date it at 686.

The contents of the plaque are an explanation of a passage from the Lotus Sutra. In the center of the composition is a large, three-story Tahoto (Fig. 126). On either side of the pagoda are five Buddhas on lotus pedestals. In the upper band of the panel are a host of small Buddhas executed, like all the other parts of the plaque, in repoussé. In the right and left sides of this band are three Buddha figures, the central one on a seat, with feet resting on a lotus pedestal. The flanking figures stand on lotus pedes-

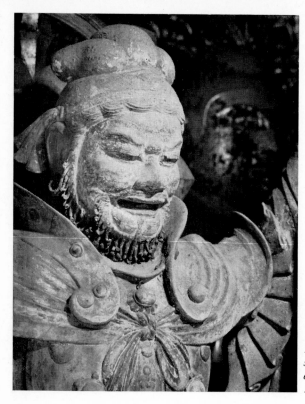

127. *Zocho Ten (one of the Four Celestial Kings; second half of seventh century). Dry lacquer; height of entire figure, 216 cm. Golden Hall, Taima-dera, Nara.*

tals. In the center of the bottom band is an inscription flanked by statues of the Nio, or Kongo Rikishi, protectors of Buddhism. The plaque clearly shows a mingling of Chinese styles in Japanese art. Though all of the figures themselves are T'ang in style, the lotus pedestal of the Tahoto, the ornamental molding, the lotus pedestals of the Buddha figures, and the holy-jewel capitals of the columns in the bottom band belong to the art styles of the Chinese Sui period. In other words, to some extent Japanese Hakuho art some sixteen years after the fire at the Horyu-ji (670) had not shaken off Sui influence.

CLAY AND DRY-LACQUER STATUES. The emergence of clay and dry-lacquer sculpture poses some new problems. In both genres the earliest Japanese examples are found at the Taima-dera temple. The clay figure of Miroku (Fig. 128), the main image of

the temple, was begun in 681, and dedication services were held for it in 685, the same year in which the dedication of the Yamada-dera bronze Buddha (Fig. 118) took place. Consequently, it is no coincidence that the surviving head of the bronze figure closely resembles that of the clay Miroku. It is true that the Miroku statue has spiral curls on the headdress and that its earlobes are less curved than those of the bronze Buddha, but the simplicity of the eyes and brow, the short nose, thick lips, round face, and full cheeks and chin are similar. The Miroku has a stately, massive body reminiscent of classical styles, though one step closer to the realism of later periods. The modeling of the flesh is subtle. The drapery crosses the chest diagonally and, passing over the left shoulder, hangs across the back, covering part of the right shoulder. The pliant expression of the fingers is excellent. Full draper-

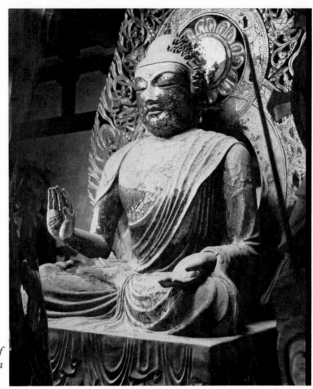

128. *Miroku Bodhisattva (685). Clay; height of figure, 223 cm. Golden Hall, Taima-dera, Nara Prefecture.*

ies fall from the massive trunk to below the legs.

The production of clay statuary at this time is not necessarily surprising, because basic forms in clay were essential to the production of cast-bronze figures. Furthermore, it is not imperative to link either the method or the style directly to influence from the Chinese mainland. Though such influence may have been at work, Japanese art had already given birth to bronze sculpture of the excellence of the Yamada-dera Buddha and was well on the path to the development of a more realistic Buddhist sculpture.

The statues of the Four Celestial Kings standing around the clay Miroku at the Taima-dera are made in dry lacquer. Works in this medium became extremely popular in the Nara period, but the kings at the Taima-dera are the oldest examples of the type in Japan. A number of processes were used

to produce lacquer statues. Sometimes the lacquer was applied to a clay core, which was later gouged out, leaving a hollow statue. Sometimes the statues were made by creating casings of cloth and lacquer on wooden frameworks. In still another method, the lacquer was applied to a wooden core that remained in place even after the statue was complete.

Of the figures at the Taima-dera (Figs. 127, 197), the one of Tamon Ten is a later addition. All the others have been extensively repaired. In style these statues seem to fall about midway between the wooden Four Celestial Kings in the Horyu-ji Golden Hall and a clay set of the same figures from the Jikido (Refectory) of the temple (Fig. 148). A static quality about their poses and the Sui or early T'ang styles of their hair, ornaments, and armor suggest that, in spite of the advanced technique

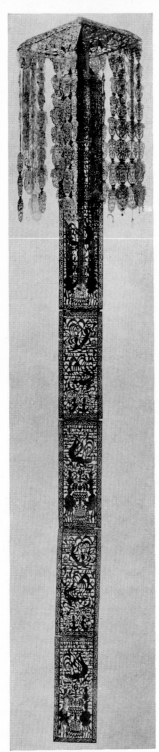

used in their production, the statues still belong fundamentally to the Hakuho period.

BANNERS Although the custom has long since gone out of practice, in the past banners made of embroidered cloth or of bronze filigree where hung as ornaments in temple halls. The most complete example of any of these banners surviving today is the Kanchoban gilt-bronze filigree banner (Fig. 129) in the Imperial Household Collection. Its total length is 5.5 meters. From the square canopy at the top is hung a chain of six rectangular plates. Each side of the canopy is ornamented with short chains of leaflike plates. The banner is decorated with wave-form scrolls, flying angels, and heavenly musicians in filigree. The workmanship throughout is excellent. A document dated 747 mentions the banner as having been donated by Kataoka Mioya no Mikoto at an unknown date. But the banner was probably made in the Hakuho period, before the fire that destroyed the Wakakusa-dera. Isolated sections of another bronze banner (Fig. 10) are part of the same collection, but the fullness of the bodies of the angels in these indicate that they were made later than the Kanchoban, probably after the reconstruction of the Horyu-ji.

Of the embroidered banner that once hung in the Horyu-ji, only fragments remain (Fig. 100). In these, angels and heavenly musicians seated on lotus blossoms and surrounded by scrolls and upward-swirling draperies are composed of outline stitches filled with solid masses of embroidery in red, green, and other colors. Since the workmanship is much more advanced than that of the Tenjukoku embroidery (Fig. 49), this banner was probably made at the time of the reconstruction of the Horyu-ji. The Tokyo National Museum and the Horyu-ji own some of the pieces of the banner; others are in private collections.

CHAPTER FOUR

The Horyu-ji Completed

MURALS IN THE GOLDEN HALL As the rebuilding of the Horyu-ji drew to a conclusion, murals were painted on the walls of the Golden Hall. At that time mural painting was a well-established technique known in the Korean kingdoms of Koguryo and Paekche. Murals have been found even in some ancient Japanese burial mounds. When they were first employed in Buddhist temples, however, is uncertain. The frequent use of embroidered hangings to decorate temple walls suggests that murals were uncommon. Moreover, their very rare occurrence in Japanese temples after the Horyu-ji seems to prove that they were not considered essential. Indeed it may be that the Horyu-ji murals were the first Japanese attempt in the genre.

An inventory of properties dating from 747 states that the clay sculptures in the Horyu-ji Pagoda and Inner Gate were completed in 711. This probably means that the rebuilding of the temple, including the murals in the Golden Hall, was finished by about the same time.

Before the fire in 1949, which destroyed some and defaced others of the murals, there were four large and eight small mural panels in the Golden Hall. Although authorities disagree on the identities of the figures and on the content of some of the panels, everyone agrees that the four large pictures represent the paradises of Shaka, Amida, Miroku, and Yakushi. The placement of the panels and their probable subjects are indicated in Figure 131.

The consensus of opinion is that the large painting on the west wall (Panel 6) represents the Paradise of Amida (Figs. 9, 132). The main figure, seated on a lotus pedestal, holds both hands at chest level in the mudra symbolizing the turning of the Wheel of the Law (i.e., the Buddha's preaching). The attendant figures on the right and left of the main figure wear coronets, in the center of each of which is a small Buddha image. Each holds a phial. These two are the Bodhisattvas Kannon and Seishi. Below the main figures is a pond with lotus blossoms on which sit lower-ranking inhabitants of paradise. The deities represented would indicate that the panel symbolizes the Paradise of Amida (also known as the Western Paradise), even if the mural were not on the west wall of the sanctuary.

The large east panel (Panel 1; Fig. 133) shows a Buddha seated on an altarlike platform in a meditation pose. The right hand is in the reassurance mudra; the left hand is held on top of the left knee (the exact mudra it represents is uncertain). In addition to the Buddha, there are two attendant Bodhisattvas and ten *arhats,* who identify the picture as a version of the Paradise of Shaka because they were his disciples.

Panels 9 and 10 are two large panels adorning the north wall (Figs. 99, 134). In Panel 10 the central Buddha is seated with both feet on the ground. This position is a variation of the cross-legged posture that, according to Sui and T'ang Chinese iconography, was reserved for Miroku. The clearest

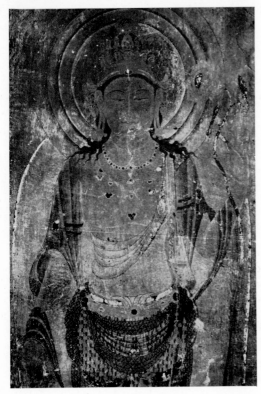

130. Eleven-headed Kannon (c. 700). Detail of mural on east wall (Panel 12). Overall dimensions of painting, 315 × 159 cm. Golden Hall, Horyu-ji. (Lost in fire, 1949.)

131. Diagram showing location of murals in Golden Hall, Horyu-ji.

KEY

Panel 1. Paradise of Shaka
Panel 2. Nikko Bodhisattva
Panel 3. Kannon Bodhisattva
Panel 4. Seishi Bodhisattva
Panel 5. Gakko Bodhisattva
Panel 6. Paradise of Amida
Panel 7. Sho Kannon
Panel 8. Monju Bodhisattva
Panel 9. Paradise of Yakushi
Panel 10. Paradise of Miroku
Panel 11. Fugen Bodhisattva
Panel 12. Eleven-headed Kannon

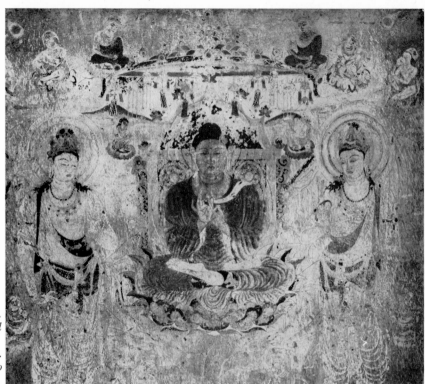

132. *Paradise of Amida (c. 700). Mural on west wall (Panel 6). Overall dimensions, 313× 260 cm. Golden Hall, Horyu-ji. (Lost in fire, 1949. See also Figure 9.)*

example of this kind of statue is the one specifically identified as Maitreya (Miroku) in the Huichien cave at Lungmen. But an example still closer in appearance is the figure in the south wall of the Horyu-ji Pagoda in a part of the sculpture series representing the Paradise of Miroku. With this strikingly similar statue to serve as substantiation, the identity of the figure in this panel is unquestioned.

The main Buddha in Panel 9 on the north wall (Fig. 135) presents more difficulties. The figure is seated with the right hand in the reassurance mudra and the left hand turned palm up, on the lap. If that hand held the jar of medicine associated with Yakushi, the Healing Buddha, identification would be simple. The jar, however, is missing. Still, the

attendant figures offer some assistance. There are two Bodhisattvas, two *arhats*, two guardian deities (Kongo Rikishi), and six Celestial Generals. The last group is certainly an abbreviation of the Twelve Celestial Generals traditionally associated with Yakushi. This further strengthens the impression that the panel represents the Paradise of Yakushi; and to add still stronger confirmation, there are dwarfs in the platform on which the Buddha sits. In the platform of the statue of Yakushi at Yakushi-ji temple there are twelve similar dwarfs thought to represent either the Twelve Celestial Generals or the twelve Yaksas (demons) associated with the generals. An almost identical picture is to be found on the walls of the Cave of the Thousand Buddhas at Tunhuang, but it seems certain that the dwarfs

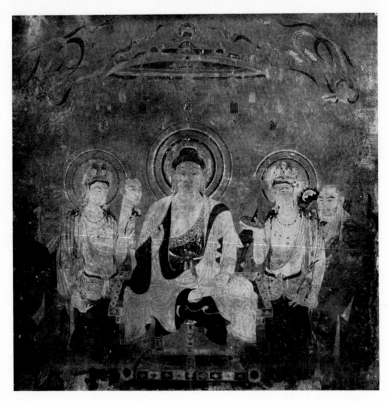

133. Paradise of Shaka (c. 700). Mural on east wall (Panel 1). Overall dimensions, 314 × 266 cm. Golden Hall, Horyu-ji. (Lost in fire, 1949.)

seen in the Horyu-ji murals are simply Yaksas.

Many different opinions have been advanced about the identities of most of the Buddhas in the large panels. Everyone agrees that the Buddha in Panel 6 on the west wall is Amida, but I seem to be the only one who thinks that the main figure in Panel 9 on the north wall is Yakushi. The reluctance to identify this figure arises from the fact that ordinarily Yakushi would not be placed on a north wall. In Buddhist iconography, direction is important; but in cases like this the content of the work ought to be the deciding factor. Since the south side of the hall, consisting mainly of openings, had little wall surface to speak of, it was necessary to put two paintings on the north side. I feel that this structural necessity forced the planners and artists to regard proper iconographic position as a secondary matter.

The Horyu-ji murals, like the door paintings on Lady Tachibana's Shrine, were influenced by mature T'ang painting. Such influence at this time is unusual. Decorous distribution of forms, rich fullness of figures, and substantial quality of costumes place the works in the Tempyo period (710–94). The drawing is smooth and fluid, the colors are rich, and the workmanship shows considerable advances over earlier paintings. The style appears to be a great development, probably based on importations from the continent. But since materials on Hakuho painting are scarce, it is impossible to trace the process by means of which these advances were made.

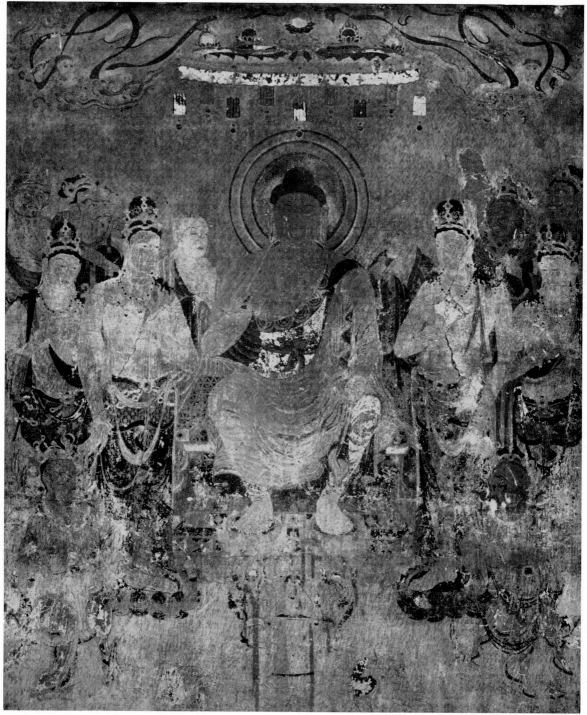

134. Paradise of Miroku (c. 700). Mural on north wall (Panel 10). Overall dimensions, 313 × 255 cm. Golden Hall, Horyu-ji. (Lost in fire, 1949. See also Figure 99.)

135. *Paradise of Yakushi (c. 700). Mural on north wall (Panel 9). Overall dimensions, 310 × 267 cm. Golden Hall, Horyu-ji. (Lost in fire, 1949.)*

136. *Detail of Yumetagai (Dream-changing) Kannon (second half of seventh century). Bronze; height of figure, 86.9 cm. Treasure Museum, Horyu-ji.* ▷

The art historian Taichiro Kobayashi advanced the theory that the works were produced in 733 by a certain Doji, who came to Japan in 718, but there is nothing to prove this hypothesis. Eizo Ota, a textile specialist, claims that the designs of the fabrics shown in the works suggest that the murals must have been made during the time of the notorious T'ang empress Wu (623–705). A comparison with sculpture in China leads me to believe that the murals were painted in the mature T'ang period. In the light of documentary evidence directly related to the Horyu-ji, it would seem that they were completed at about the same time as the clay sculpture in the Pagoda and Inner Gate: in 711, or forty-one years after the fire that burned the original temple to the ground. However, stylistic evidence seems to indicate a different date. The murals on the main walls of the Golden Hall, paintings of angels and *arhats* in the inner sanctuaries of the Golden Hall and Pagoda, and also paintings on the ceilings and graffiti found in the roof, all exhibit a stylistic continuity, and it is difficult to imagine a gap of any length of time anywhere. This suggests that the murals were completed at the same time as the Golden Hall itself —about 680 to 690. Dating them exactly, however, remains a difficult task.

SCULPTURE IN THE PAGODA Four walls surround the centerpost on the first level of the Pagoda interior. On the wall surfaces, grotesquely undulating grottos made of

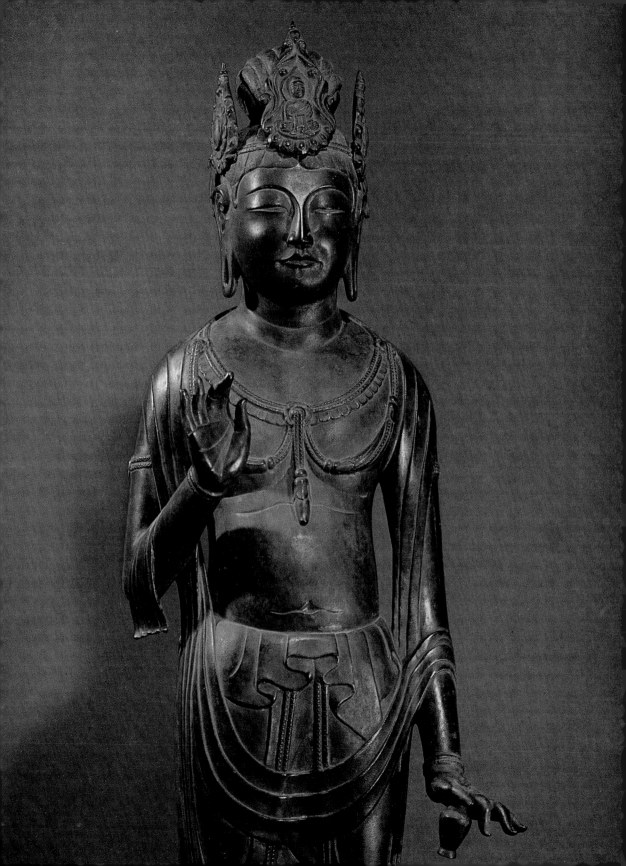

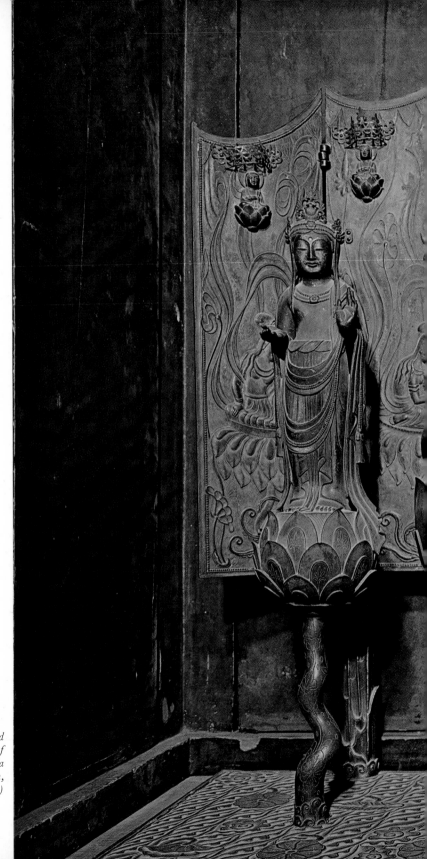

137. Lady Tachibana's Shrine (second half of seventh century). Detail of Amida Triad. Bronze; height of Amida figure, 33.3 cm. Treasure Museum, Horyu-ji. (See also Figures 114, 115.)

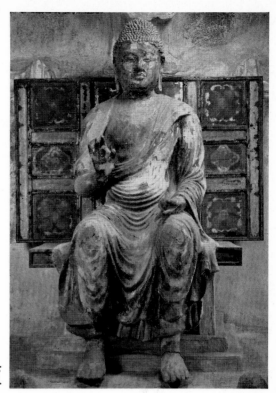

143. *Miroku Bodhisattva (711). Clay; height of figure, 55.4 cm. Pagoda, Horyu-ji.*

clay form four niches, one to each wall. The grottos serve as the background for four sets of clay statues representing the Death of the Buddha, the Division of the Relics, the Colloquy between the Bodhisattva Monju (Manjusri) and Yuima (Vimalakirti), and the Paradise of Miroku. Each of the groups explains points of great importance to Buddhist faith.

The scene between Yuima and Monju (the east set) illustrates a profound philosophical passage in the *Yuima Sutra*. Yuima, a Buddhist layman who is ill out of sympathy for the suffering that all sentient beings undergo, is seated and leaning on a low, one-legged desk (Fig. 138). Although in the end he will fall into silence, at this point Yuima has his mouth open and is gesturing with both hands as if saying something to Monju. The full-bodied,

graceful Monju (Fig. 139) seems to be prepared to reply. Dressed in richly flowing garments, he wears his hair piled high in an elaborate and princely coiffure. Around him are other Bodhisattvas and heavenly beings, whose bodies and clothing resemble his very closely. Monju looks so much like the figures in the murals of the Golden Hall that he might almost have stepped out of one of them. On the lower levels of the grotto, worldly beings—men, women, children, monks—who are closely following the colloquy between the two Buddhist saints, kneel in a decorous manner. Floating on clouds are the precious seat and fragrant rice that Yuima is thought to have had sent from Treasure Land.

The south set of figures centers on a statue of Miroku on a seat (Fig. 143). With the exception of

144. *Division of the Relics (711). Clay. Pagoda, Horyu-ji.*

Miroku, all of the figures have been very clumsily repaired. Like the Miroku scene in the murals of the Golden Hall, this group represents the Paradise of the Buddha who will come to save mankind in the remote future.

On the north side of the Pagoda is the Death of Buddha, or the Buddha's entry into Nirvana. The gilded figure of the Buddha reclines on a low bed-like platform, an old woman kneeling in front of him. Surrounding the Buddha, his ten principal disciples wring their hands, wail, and weep in grief over his passing (Fig. 145). These figures, which are aligned in the foreground, are so vivid that their sorrowful cries seem to echo through the rocky grotto. Farther in the background are dragons, angels, and demons. Still farther among the boul-

ders in the distance are human figures, including monks, men, and women. Reduced in size to create a sense of depth, these figures too weep and bewail the loss of the Buddha.

In the scene of the Division of the Relics, the set of statues on the west, a group of followers of the Buddha kneel in formal poses on either side of a golden coffer, placed well back in the grotto, and a reliquary, placed slightly forward.

All of the clay statues in the Pagoda are built up on a layer of straw over a wooden core. Coarse clay around the straw produces the rough shape of the figure. Several additional layers of finer clay create the finished form, and the statue is then painted in colors. This method, learned from the continent at about the time when the Horyu-ji statues were

145. *The Ten Great Disciples of Buddha (711). Clay; height of central figure, 40.2 cm. Pagoda, Horyu-ji.*

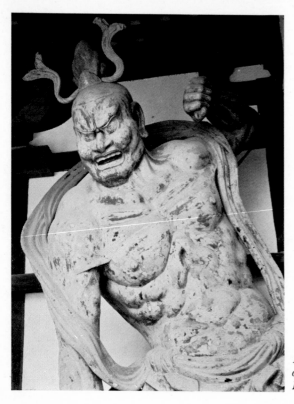

146. *Kongo Rikishi (711). Clay; height of entire figure, 378.8 cm. Inner Gate, Horyu-ji.*

made, is seen in a somewhat older figure at the Taima-dera. Clay is better suited to producing the soft, natural qualities of flesh than cast bronze or any of the other materials that must be chiseled. It was so popular during the Tempyo period in Japan that it seems to have represented almost a sculptural ideal of the age. Clay statues made in Japan at this time closely resemble terra-cotta figures of the mature T'ang period in China.

OTHER CLAY SCULPTURE The Nio, or Kongo Rikishi as they are often called, are guardian deities who have vowed to protect Buddhism. Their ferocious facial expressions and postures are supposed to frighten away beings intending to harm Buddhism. The first known

representations of these deities in Japan are the two figures on the repoussé bronze plaque at the Hase-dera. (See page 119.) The two clay statues in the Inner Gate of the Horyu-ji (Fig. 146) are second in age to the Hase-dera Kongo Rikishi. They have been extensively repaired over the centuries. In contrast to the generally static Hakuho-period versions of these guardians, the Horyu-ji Kongo Rikishi display intense dynamism in face and body.

Although the clay figures in the Pagoda, especially the statue of Monju, retain traces of older styles, those from the Jikido are already in the mature style of the Tempyo period. These statues were not originally made for the Horyu-ji, but were brought to their present place from another temple at an uncertain time. The group consists of statues

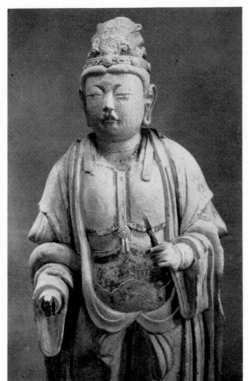

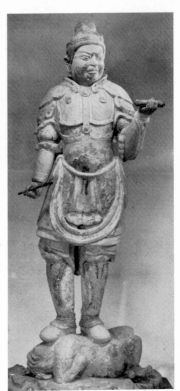

147 (right). Taishaku Ten (first half of eighth century). Clay; height of entire figure, 109.4 cm. Treasure Museum, Horyu-ji. (Originally in Jikido.)

148 (far right). Komoku Ten (first half of eighth century). Clay; height of figure, 160 cm. Treasure Museum, Horyu-ji. (Originally in Jikido.)

of the Healing Buddha, Yakushi; Taishaku Ten (Fig. 147) and Bon Ten (Fig. 141); and Four Celestial Kings (Figs. 140, 148). The figure of Yakushi, which has suffered extensive damage and undergone many repairs, seems very old. It sits on an altarlike platform that is probably of the same date as the statue. The robe and draperies fall to the front in generous folds. In all likelihood, this representation of Yakushi belongs in the group of which it now forms a part.

In Indian iconography it is possible to distinguish between Indra (Taishaku Ten) and Brahma (Bon Ten) by means of their headdresses and the accessories they hold. This is not the case with the Jikido clay statues. Both Taishaku Ten and Bon Ten have similar headdresses and small coronets;

both wear leather armor over which is cast a loose-fitting garment. In the case of Taishaku Ten, this garment is tied in the front (Fig. 147). In both figures, the bodies are full and seem almost to swell outward. The hips of Bon Ten are somewhat heavy. Because the armor is worn loosely, the statues lack the sense of tension seen in similar clay statues of T'ang Chinese sculpture. There are very few folds in the lower garments, and no elaborate jewels ornament the body. At one time, these dignified and elegant figures were painted, but all of the colors have worn away, exposing the fine white clay in which small glittering particles are visible.

The statues of the Four Celestial Kings too were once painted, but their colors have largely disappeared (Figs. 140, 148). The collars on the armor

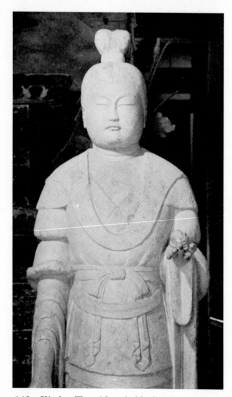

149. Kissho Ten (first half of eighth century). Clay; height of figure, 166.3 cm. Golden Hall, Horyu-ji.

characteristics, a clear departure from the rigid frontality of works of the Asuka and early Hakuho periods, suggest a trend toward freedom and naturalistic representation. The movement of the eyes and the bodily postures give the impression that the statues are about to move. Action is especially evident in the facial expression of the statue of Zocho Ten (Fig. 140).

In addition to these clay statues, there is a stately, serene clay figure of Kissho Ten (Srimahadevi), the goddess of happiness and good fortune (Fig. 149), in the Golden Hall. Completely frontal in orientation, the figure (166 centimeters tall) was probably intended as an object of worship in religious ceremonies.

EAST PRECINCT OF THE HORYU-JI With the completion of the Inner Gate in 711, the major construction of the West Precinct of the Horyu-ji drew to a close. It is true that some building work in that part of the temple continued into the Tempyo period (710–94). But the most active construction projects of that time took place in the East Precinct. Before discussing that part of the temple and its buildings, however, I must say a few words concerning the religious faith that developed around Prince Shotoku.

I explained earlier some of the important activities in which the great prince and regent Shotoku was involved. He participated in the reordering of Japanese government by issuing the so-called Constitution of Seventeen Articles. He established a system of twelve imperial court ranks, he promoted contacts with Sui-period China, and he did much to make Buddhism a thriving religion in Japan. After his death, however, his entire family suffered miserably at the hands of the Soga clan, and ultimately, with the passing of the prince's son, the line died out. The burning of Prince Shotoku's Ikaruga Palace was an immense tragedy for the common people, who sympathized with and revered the prince. In fact, reaction against the hardships endured by Shotoku's family may have prepared the soil for a wide dissemination of religious faith in the great man.

are smaller than those of the kings at the Taimadera and in the Horyu-ji Golden Hall. The upper parts of the armor form lions' heads with open mouths from which the statues' arms emerge. Sashes are tied around the waists, their ends arranged in wide, curving loops. Each of the figures surmounts a demon. Some distinctive features appearing in Japanese representations of these divinities for the first time indicate stylistic shifts that were to culminate in a new kind of Buddhist sculpture in the following periods. The figures stand with eyes open wide and turned at an angle. Between the brows are deep wrinkles. The mouths too are open, and the lower jaws and cheekbones are prominent. The heads are turned to the side. All of these

There are many legends about the virtual deification of Prince Shotoku. Some of them are very old. For instance, a record that was probably used in the compilation of the *Chronicles of Japan* contains an entry for the year 593 in which prodigies are attributed to him. His mother is supposed to have experienced no labor pains. The child is said to have spoken from the time he was born and to have been enlightened in wisdom. He could listen to the appeals of ten people at a time and accurately solve all their problems. He was always eloquent and seems to have been able to foresee future events. He studied under outstanding monks and made excellent progress in his studies. He was devoted to his father, Emperor Yomei.

An entry for the year 622 describes the way in which worship of the prince came about. It is said that the monk Eji, who had come to Japan from the Korean kingdom of Koguryo, was deeply grieved on hearing of the death of Prince Shotoku. He requested other monks to establish worship for the prince's sake. On days when he himself expounded the sutras, he proclaimed that Shotoku was a holy man approved of by heaven, and possessed of miraculous virtues. The monk added that Prince Shotoku had experience of the Three Worlds (Heaven, Earth, Humanity), that he was the recipient of the wisdom of past sages, and that he could save men from dark misfortunes.

Veneration of the prince gradually spread until it became popular to represent him in paintings and to discuss his connection with teaching the sutras. One of the most famous pictures of Shotoku (Fig. 150) is part of the collection of treasures presented to the Imperial Household by the Horyu-ji. Although the picture is arranged like a triad with Shotoku in the center and a prince on either side, to avoid too close a comparison with triads centering on a Buddha, the artist has turned the three figures to face slightly to one side instead of to the front. The style of the painting is of the Hakuho period and bears traces of the influence of Chinese painting of the Southern and Northern Dynasties (420–589) and the Sui period. The figures are slender, much like those in the paintings on the doors of the Tamamushi Shrine (Figs. 35–38).

150. *Portrait of Crown Prince Shotoku (second half of seventh century). Traditionally attributed to Prince Asa. Colors on paper; overall dimensions, 125 × 50.6 cm. Imperial Household Collection.*

The Horyu-ji monk Gyoshin was much saddened by the neglected state of the site of Prince Shotoku's Ikaruga Palace. Determining to do something to rectify the situation, he discussed the matter with Princess Abè, who later became Empress Koken. As an outcome of this discussion and as a result of Gyoshin's industry, the East Precinct of the Horyu-ji was built on the site of the destroyed palace. Many articles said to have belonged to Shotoku were stored there. The layout of the East Precinct consisted of a centrally placed octagonal hall, surrounding corridors, an inner gate, and a south gate. On the north were a lecture hall, other outbuildings, and monks' quarters. All of the structures were roofed with cypress-bark shingles.

152 (opposite page, top). Yumedono ▷
(739). Height, 12.62 m. Horyu-ji.

153 (opposite page, bottom). Yumedono ▷
(739) seen beyond the corridor of the East
Precinct. Horyu-ji. (See also Figure 152.)

151. Yumedono (739). Relic urn on roof.
Horyu-ji. (See also Figure 152.)

In 1939, during repairs on the East Precinct, excavations revealed some things that had been on the site since the palace stood there. It was learned that the buildings originally built on the site had sunken posts and were placed at right angles to each other in a plan that resembles the one used in a later residential architectural style called *shinden*. Three buildings were long in the north-south axis and one long in the east-west axis. The courtyard was spread with gravel. Part of a burned wall, an outdoor well, and traces of a small riverbed were discovered.

It is known that the present Dempodo, or Lecture Hall, was donated to the temple in 746 and that the octagonal hall (Yumedono) was completed by 739. In its existing form, the octagonal hall stands on a two-level granite platform (Fig. 152), but it seems that the original platform was of only one level and was made of tuff. The former roof was unlike the one on the hall now: its pitch was lower and its

eaves did not project as far as they do today. The impression of the older hall was probably light, since the distance from the eaves' ends to the plate on which the finial ornament rested was only about two-thirds what it is at present. This finial ornament is in the shape of an urn like the one represented in the Division of the Relics scene in the Pagoda. This is suited to the nature of the building as a place in which to worship Prince Shotoku. The main image inside the hall is the Yumedono Kannon, which I have already described in detail. (See page 69.) The statue was probably made for another temple that had some connection with the Horyu-ji and was moved to the octagonal hall at an uncertain time. Supposed by some to be a portrait of the prince, it is kept in a handsome black-lacquer shrine of more recent construction. Formerly four octagonal-section posts supported the flat diamond-lattice ceiling.

The name Yumedono, or Dream Hall, has been

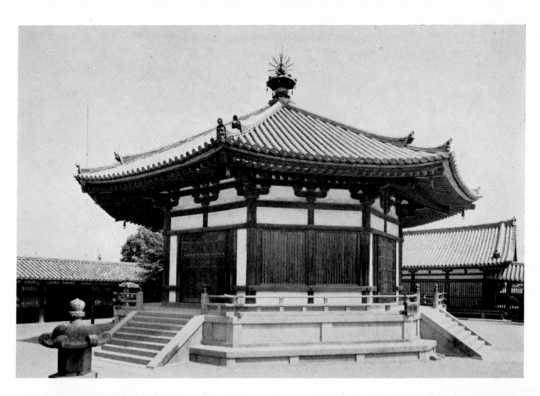

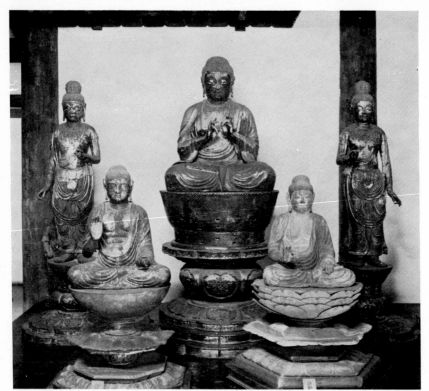

154. Amida Triad (second half of eighth century). Dry lacquer; height of Amida, 119 cm. The smaller statues in the foreground represent Amida (left) and Yakushi (right). Dempodo, Horyu-ji. (See also Figure 155.)

given to the octagonal hall because of a popular tradition associated with Prince Shotoku. It is said that when the prince meditated here on the meaning of a scriptural passage, a golden Buddha would appear to him in a dream and explain its meaning. Since the Yumedono was not erected until after Shotoku's lifetime, the account would seem to be spurious. However, as the only octagonal hall among several rectangular ones, and with its strange finial, the unusual appearance of the Yumedono does somehow seem to have a dream-like quality about it.

The Dempodo lecture hall of the East Precinct is a long, slender building (seven by four bays) with an elevated wooden floor. Three Amida triads stand on the long altar (Figs. 154, 155). In its original form, the building had a raised wooden floor, a cypress-shingle roof, and an open end-section four bays long and two bays deep. In other words, the hall was a residential structure, probably the eastern outer building of a *shinden*-style mansion. This lends credence to the tradition that the lecture hall was once the residence of Lady Tachibana, whose daughter was Komyo, consort of Emperor Shomu (724–49). In 746, Lady Tachibana devoted a set of forty-nine volumes of the *Yakushi Sutra* to the temple. It is possible that the building was moved at that time too. All of the Amida groups inside the Dempodo are dry-lacquer statues of the late Tempyo period. The group in the easternmost bay is the best balanced.

The present Shariden (Relic Hall) and Edono

155. Statues in the Dempodo (second half of eighth century). Dry lacquer; height of figure of principal image, 119.6 cm. Dempodo, Horyu-ji. (See also Figure 154.)

(Portrait Hall), in front of the Lecture Hall, were a single room in the Nara period (646–794) and, according to an inventory of East Precinct possessions, housed the personal effects of Prince Shotoku. In the past, what is now called the Worship Hall, standing between the South Gate and the Yumedono, was in fact the Inner Gate. It was rebuilt to serve as a place from which to offer reverence to the Yumedono itself. The corridors starting at the sides of the Worship Hall and leading to the Shariden and the Edono originally passed in front of these two rooms. In other words, in its first state, the Yumedono stood alone in the gravel-spread courtyard. Today the corridors lead to the Shariden and Edono. Between these two rooms is a passage leading to the Lecture Hall in the rear. The

belfry to the west of the compound was built at a later time.

Inside the Yumedono are two fine examples of early Japanese portrait sculpture: the dry-lacquer statue of Gyoshin (Fig. 142) and the clay statue of another monk, Dosen (Fig. 156). I have already mentioned Gyoshin in connection with his efforts to express respect for Shotoku's memory by building the East Precinct on the site of the old Ikaruga Palace. In his early days, Gyoshin was attached to Hoko-ji temple. After studying the Buddhism of the Hosso sect and other teachings, he ultimately became attached to the Horyu-ji. The temple still preserves a large number of sutras that are said to have been copied at the request of Gyoshin. The statue of this monk, made during the Tempyo pe-

156. Detail of statue of the monk Dosen (second half of ninth century). Clay; height of figure, 88.2 cm. Yumedono, Horyu-ji.

riod, when the art of dry-lacquer sculpture was at its peak, is a masterpiece of portrait sculpture on a par with the famous statue of Ganjin kept in the Toshodai-ji. The head is somewhat pointed, the eyes rise at the ends, the neck is thick, and the ears large. The body is a flawless interpretation of dignity. It is said that the statue was made after Gyoshin's death by an artist who was familiar with the monk's appearance. The man must have gone to work soon, because his statue is imbued with unmistakable personal individuality that must have come from direct experience of the subject.

Dosen, who lived about a century after Gyoshin, was a famous scholar at the Horyu-ji. He instituted a one-hundred-day summer lecture course on three sutras and began the repairs on the East Precinct of the Horyu-ji that were carried out during the middle part of the ninth century. In 876 Dosen died. It is said he was in the formal kneeling position at the moment of his death. The clay statue of him in the Yumedono was made after the true peak of this art form, but it nonetheless vividly portrays the warmth and gentleness of the monk. It is interesting to contrast the personalities of the two men as represented in these statues.

LATER BUILDINGS OF THE WEST PRECINCT Of the buildings in the West Precinct, so far we have dealt in detail with the Golden Hall and the Pagoda. Here I will

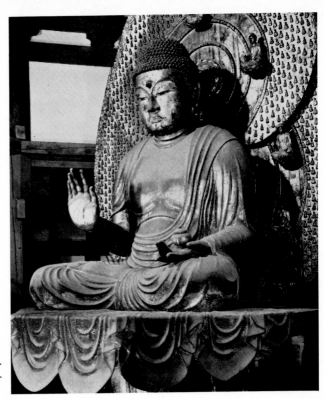

157. Yakushi Buddha (second half of eighth century). Dry lacquer; height of figure, 242.4 cm. Saiendo, Horyu-ji.

mention briefly the other buildings. The Sutra Repository, East Quarters, West Quarters, and East Main Gate were built in the Nara period, as were monks' quarters called Kitamuro (North Quarters) and a refectory. The last two are no longer extant. The Belfry and a lecture hall no longer extant were added in the Heian period (794–1185). Later, the south ends of the West and East Quarters became chapels called Sangyoin and Shoryoin, respectively, the present Lecture Hall was built on the site of the former refectory, and the Belfry and Sutra Repository were taken up into extensions of the corridors. The date of the so-called Government-sealed Repository (Kofuzo) southeast of the present Refectory complex is not known, but the building is reminiscent of the storehouses called *narabigura,* or paired repositories, of the Nara period.

To the northwest of the main compound is the West Round Hall (Saiendo). This has been repaired a number of times. It has tuff foundations and rests on a two-level earthen platform of octagonal plan. The shape of this altarlike pedestal platform proves at least that the building has been octagonal since it was first built. The dry-lacquer main image of the hall can be identified as Yakushi because of the container of medicine he holds in his left hand. This statue, the body of which is full and dignified, is an excellent example of late-Tempyo art (Fig. 157).

Origins and Sources of Japanese Buddhist Sculpture

FROM INDIA TO JAPAN Although the Buddhist religion first came into being on the banks of the Ganges in the fourth century B.C., representations of the Buddha were not made until hundreds of years later. What may be called the earliest Buddhist art was confined to stupas, temples, and relief sculpture of goddesses, demons, and similar beings. But no representations of the Buddha were produced. When it was necessary to illustrate points in the traditional versions of the life of Shaka, such symbols as trees, thrones, and the Wheel of the Law were used in place of statues or paintings of the Buddha himself. The reason for this apparently deliberate avoidance of Buddha representations is not certain, but the attitude persisted for a long time.

The first statues of Buddha may be traced to the first half of the second century A.D., when works of this kind were being produced in Gandhara on the upper reaches of the Indus in the reign of King Kanishka of the Kushan dynasty and at Mathura on the river Jumna. Representative statues from these places (Figs. 158, 159) all seem to date from about the same time, though the presence of Greeks and the obvious influence of Greek art in Gandhara

suggest that this region may have produced such sculpture somewhat earlier. The Gandhara Buddha statue shown in Figure 161 has a decidedly Greek look and even resembles sculpture of the Greek god Apollo. The eyes are graceful, the lines of the nose clear, and the mouth beautiful. The heavy drapery is realistically portrayed and is wrapped around the body in Greek fashion. Bodhisattvas in art of this time and region have elegant faces and powerful bodies. The jewels and crowns they wear are a blend of Indian and Central Asian styles.

Many of the figure types of Gandharan sculpture are ultimately based on Greek and Roman forms. For instance, the Buddhist Kongo Rikishi guardian deities derive from representations of Hercules; those of the Yaksa demons from atlantes; and those of the Dragon King from Triton. In contrast, the fleshy forms, soft qualities, and diaphanous draperies of statues from Mathura (Fig. 159) reveal Indian origins. The traditions of Gandhara were later to spread into Afghanistan and throughout Central Asia as Kushan art. The art of Mathura eventually gave birth to Gupta art.

Because of its geographical proximity, the Kushan empire was the source of the earliest

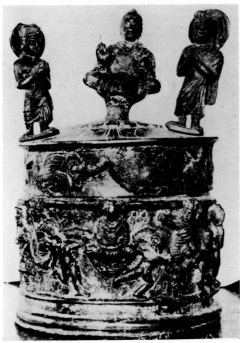

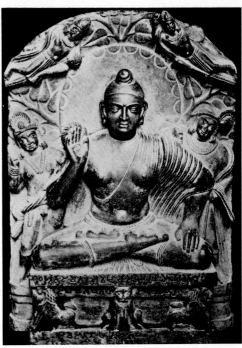

158. *Reliquary of King Kanishka (first half of second century). Bronze; height, 19.7 cm. Archaeological Museum, Peshawar, Pakistan.*

159. *Mathuran relief of Buddha (first half of second century). Stone; overall height, 69 cm. Curzon Museum of Archaeology, Mathura, India.*

Buddha statues transmitted to China. No large examples of these have survived, though Buddhas and Bodhisattvas are seen on mirrors, ceramics, and sometimes in small gilt-bronze figures (Fig. 160). This kind of statuary continued to be popular until the fourth century. In the fifth century, however, with the beginning of the epoch of division between north and south, Chinese Buddhist sculpture began to develop along its own lines.

In India, as the power of the Kushan empire declined, Buddhist sculpture gradually began to deteriorate. This is not to say that it disappeared completely. But there were no new developments and it fell into mannerism (Figs. 161, 162). The Kushan empire had seen the last of its united power. But the art of the Guptas gradually attained ascendance as the Gupta empire in central India moved toward its apogee.

As the northern T'o-pa people, who were to found the Northern Wei dynasty, established their power, Chinese Buddhist sculpture began its own course of development, though it continued to be based on the Kushan styles and to be influenced by Gupta art. The style produced by the Chinese at this time has come to be called Yunkang after the Yunkang caves in north Shansi Province. These caves, which were begun in 460 before Wei moved its capital to Loyang, do not present a full picture of the art of the fifth century, but examples earlier than these caves are extremely rare. The Buddhas of the Yunkang style are massive and dignified; they have nobility in simplicity. The heavy, soft-looking bodies are covered in thin garments of the style found in Gupta art. In addition, the spiral curls of Gupta-style Buddhist headdresses sometimes appear in Yunkang works. The mandorlas,

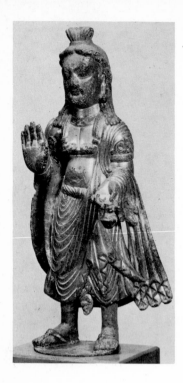

160. *Bodhisattva (late third to early fourth century). Bronze.*

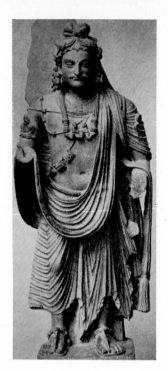

161. *Gandharan Buddha (third century). Stone; height of figure, 109 cm. Museum of Fine Arts, Boston.*

however, are boat shaped, as they will remain in Chinese art until such works of the Northern Ch'i and Northern Chou as those in the caves of Hsiang-t'ang-shan on the borders of Honan and Hopei provinces.

The history of Chinese Buddhist sculpture of the early period rests on materials from the northern part of the country because little remains from the art of the Yangtze region. Fortunately, a small, seated bronze Buddha from the Liu Sung period (420–79) and traditionally dated 437 (Fig. 164) gives an idea of what sculpture of the kind was like in south China. A comparison of this statue with the small Northern Wei Buddha dated 443 (Fig. 165) immediately reveals the difference between what are usually called northern simplicity and southern elegance. The comparison of these two statuettes with another produced in 429 (Fig. 166), during the short-lived Hsia dynasty (407–31) of the

tribal Hsiung-nu, in the Ordos vicinity of Inner Mongolia, shows how simple and conservative the art of the northwestern regions was in this period. In 431, Northern Wei conquered the Hsiung-nu Hsia and thus unified the northern part of the country and opened doors for contacts with the West. In 493–94, the Northern Wei capital was moved from P'ingch'eng (modern Tat'ung) to Loyang. With this historically important move, there occurred a shift in Buddhist sculpture styles from the simple grandeur of the caves of Yunkang to the classic grace of what was to become the Lungmen style. The sculptures of the northern and southern parts of the country began to fuse.

The Lungmen style reached the Korean Peninsula by two routes. Coming by land, it arrived first in Koguryo and then passed into Paekche. But it was also transferred to Paekche from the south by sea. Although there are some small differences in

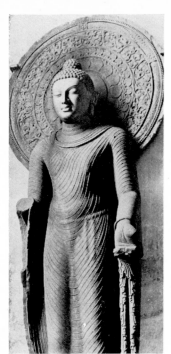

162 (left). Mathuran Buddha (fifth century). Stone; height of figure, 217 cm. Indian Museum, Calcutta.

163 (right). Northern Wei Buddha in Cave 19 (460–80). Sandstone. Yunkang, China.

the style according to the quarter from which it arrived, Japan invariably received the art of Lung-men from Paekche and not directly from China.

The few available documents dating from the earliest period of Japanese borrowings from Chinese culture state that these styles were brought to Japan by Korean craftsmen, but the existence of two routes of cultural transfer is apparent from ancient roofing tiles. For instance, among Asuka-period Japanese tiles are some bearing lotus patterns that belong to the northern, or Koguryo, school, and others with patterns traceable to the southern, or Paekche, style. In the late fifth and early sixth centuries, Paekche and Koguryo were the advanced kingdoms on the Korean Peninsula. The third kingdom, Silla, like Japan, was underdeveloped and eager to adopt whatever elements of higher culture came its way.

Although the history of Korean Buddhist sculp-ture is important to Japanese art, it is difficult to assign exact dates to any of the material available. But three statues of Korean origin and one mandorla that may have come from Korea (now in the collection of treasures presented by the Horyu-ji to the Imperial Household) shed some light on Korean art of the sixth century. The mandorla (Fig. 167), called the Mandorla of the Year Koin, can be dated 534. It was part of a gilt-bronze figure of Shaka. A bronze statue of Buddha with a mandorla, known to have been made in Koguryo (Fig. 168), dates from 539. Another, also made in Koguryo (Fig. 169), dates from 571, and a mandorla made in Paekche (Fig. 170) dates from 596. All of these works are comparatively conservative; all four remain faithful to the styles of Northern, Eastern, and Western Wei that were popular in China in the 520s and 530s.

In addition to statues of the Buddha, works

164. *Buddha (437). Bronze; height of figure, 21.9 cm.*

165. *Northern Wei Buddha (443). Bronze; overall height, 53.5 cm.*

166. *Buddha (429). Bronze; overall height, 19 cm.*

depicting standing Bodhisattvas and Bodhisattvas in the so-called meditating pose give information on the Lungmen style in the second half of the sixth century. For instance, the graceful Miroku of the Koryu-ji (Figs. 78, 171), the stone Miroku known to have been made in Silla (Fig. 172), and another lovely torso made in Koguryo (Fig. 173) are cases in point. Although Lungmen styles of the Northern Wei were still fashionable in the late sixth century, in the first half of the same century, statues in the styles of Ch'i and Chou had already become accepted and popular in Korea.

In general terms it is possible to describe early Japanese Buddhist sculpture as being under the influence of Northern, Eastern, and Western Wei works through the first half of the seventh century and under the influence of Ch'i and Chou sculpture in the second half of the seventh century. It is true,

then, that a considerable time gap existed between what was popular in China and what was being made in Japan. But this is not to say that conservative Japanese art remained unaffected by continental influences. On the contrary, new things were tried in Japanese sculpture from time to time. Some of the statues discussed in the earlier chapters of this book illustrate my point. For example, the ornamental knot of the draperies in the lower part of the costume of the Yumedono Kannon (Fig. 51) and the thick bodies of the Four Celestial Kings (Fig. 72) were new style elements when these works were made. It is unquestionable that the Yumedono Kannon and the Amida Triad of Lady Tachibana's Shrine were influenced by Chinese styles of the Ch'i and Chou periods. The murals, clay statues, and dry-lacquer statues in the Horyu-ji Golden Hall bear witness to importation of styles from the Sui

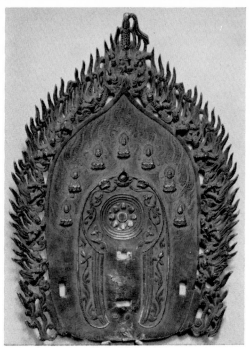

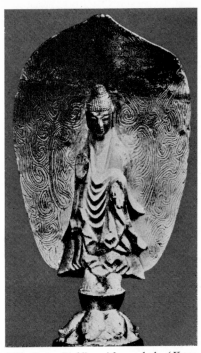

167. Mandorla (534). Bronze; height, 31 cm.

168. Shaka Buddha with mandorla (Koguryo; 539). Bronze; height, 17 cm.

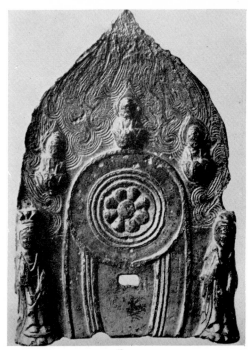

169. Shaka Buddha with mandorla (Koguryo; 571). Bronze; height, 11.4 cm.

170. Mandorla (Paekche; 596). Bronze; height, 12.4 cm.

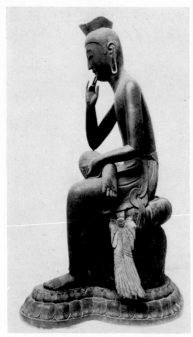
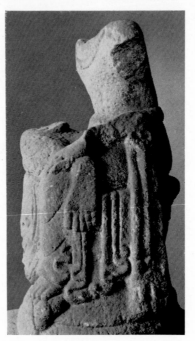

171. Miroku Bodhisattva (first half of seventh century). Wood; height of figure, 123.5 cm. Koryu-ji, Kyoto. (See also Figure 78.)

172. Miroku Bodhisattva (Silla; sixth century). Stone. Kyongju Museum, Korea.

173. Torso of figure in half-lotus meditation posture (Koguryo; sixth century); excavated at Panla, China. Stone; height, 11 cm. University of Tokyo.

and T'ang periods. In the transmission of influences from China and Korea, emissaries dispatched to Silla and Paekche and to Sui and T'ang China played an important part. Interestingly, the number of emissaries to China reached two peaks, which correspond to the high points of the Asuka period (from about 610 to about 630) and the Hakuho period (from about 660 to about 670).

After the radiating influence of the Gupta empire and its art, no single nation affected Chinese art in a total fashion, though in the late sixth century such foreign traits as the thin veiling draped over statues of Vairocana (Rushana) were to appear in China. In the seventh century, the Sui and then the T'ang dynasties unified and brought the nation to a peak of glory and power. In India, at about the same time, Emperor Harsha had led his nation to an apogee of wealth and power. The two greatest

countries in the Asian world quite naturally engaged in cultural exchange. The outward-swelling, fleshy look, the pliancy of body and limb, and the slight sway in the posture that became characteristics of Sui and T'ang sculpture (Figs. 174, 175) derive from Indian art. It seems almost as if the Buddha and Bodhisattva figures of the tropical lands to the south opened the eyes of the Chinese to the natural appearance of the human body. These natural qualities found expression in the heightened realism of the sculpture and painting of the T'ang period.

Many things introduced into China from India at this period in history were to have lasting effects on Buddhist art. The famous Chinese pilgrims Hsuan-tsang and Wang Hsuan-ts'e, who traveled to India in the seventh century, brought back with them an unusual crowned Buddha statue that

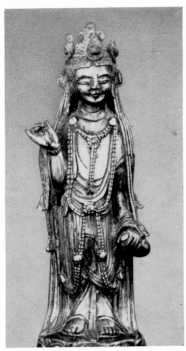

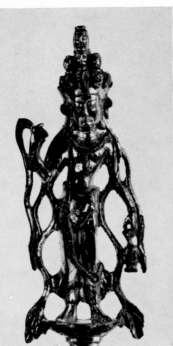

174. *Bodhisattva (Northern Wei; 532). Bronze; height of figure, 23.6 cm. Nezu Art Museum, Tokyo.*

175. *Eleven-headed Kannon (Sui; c. 600). Bronze; overall height, 23.6 cm.*

176. *Detail of Shaka Preaching (eighth century). Silk embroidery. Nara National Museum.*

played an important part in later esoteric Buddhist painting and sculpture. Some other esoteric art themes—angels and figures of Bodhisattvas, notably Kannon, with many heads or arms—derived from sources that were more ancient Indian than strictly Buddhist. A famous statue type called the King Udayana statue, after the Indian king who is traditionally believed to have commissioned the very first Buddha statue (during the lifetime of the historical Buddha, Shaka), was actually a new interpretation of the Kushan art of Gandhara. This style too passed into China from India, as did the use of a thronelike chair with a high back and canopy for representations of the Buddha (Fig. 176).

The naturalism of Sui and T'ang Chinese art owed much of its inspiration to Indian sources. The styles popular in China at the time later passed into Japan, where they were directly reflected in the art produced during the Hakuho period. For example, Hakuho statues of Bodhisattvas show a fleshy, almost voluptuous, realism in many of their details and often stand in the slightly swayed posture already discussed in connection with T'ang sculpture. Although the so-called crowned Buddha statues were not produced in Japan until a later age when esoteric Buddhism was popular, even in the Hakuho period, statues of multiheaded, multiarmed deities were made. They generally have a distinctly natural, sometimes almost voluptuous, appearance. The high-backed throne, too, is found in such Japanese works as the statue of Miroku in the Horyu-ji Pagoda (Fig. 143), the Amida panel in the murals of the Horyu-ji Golden Hall (Figs. 9, 132), and the embroidered Buddha of Kanju-ji temple (Fig. 176).

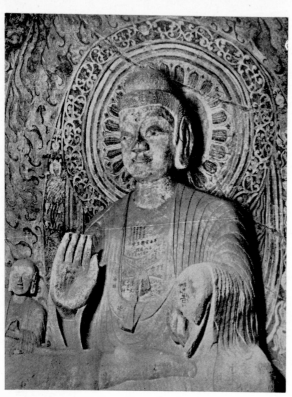

177. Shaka Buddha (Northern Wei; 523).
Sandstone. Pinyang Cave, Lungmen, China.

178 (opposite page, left). Bodhisattva (Paekche; ▷
second half of sixth century). Overall height, 11.5
cm. National Museum of Korea, Seoul.

179 (opposite page, center). Bodhisattva (East- ▷
ern Wei; first half of sixth century). Overall
height, 8 cm.

CONTINENTAL
COUNTERPARTS

HORYU-JI SHAKA TRIAD. The Shaka Triad in the Golden Hall of the Horyu-ji is at once a masterpiece of Asuka-period sculpture and one of the most important works in the history of Japanese sculpture as a whole. Since the group is known to have been made in 623 for Prince Shotoku, it may be considered a standard of unquestioned authenticity for the style of the Asuka period. Prototypes from which this Asuka style evolved are found in both China and Korea, but the one corresponding most closely is the Northern Wei statue of Buddha in the Pinyang cave at Lungmen (Fig. 177). The time that this style took to reach Japan from China by way of Korea is a somewhat long one hundred years. The Pinyang group was completed sometime between 505 and 523.

Korean materials on sculpture of this period are too rare to make it possible to locate anything that definitely corresponds to the Shaka Triad at the Horyu-ji. Still, taken together, the mandorlas and Buddha figures in Figures 167 through 170 and the standing Bodhisattva figure in the Toksu Palace Museum of Fine Arts, Seoul (Fig. 187), provide grounds for seeing at least the kind of work on which the Japanese versions of the style were based. The style seen in these works, called Northern Wei Lungmen style, is comparatively late, falling in the decade between 540 and 550. A standing Bodhisattva with flaring coronet ribbons (Fig. 178) comes from the Korea of about the same time and is considered to belong to the Lungmen style. A Chinese work (Fig. 179) corresponding to this Bodhisattva dates from the period between 510 and 550. It is not surprising that the style should arrive in Japan at the beginning of the seventh century,

180. Buddha (Eastern Wei; 536). Bronze; overall height, 61 cm.

since it was employed throughout the sixth century in Korea.

Examinations of the kind of hair in the head-dresses of the statues of this period in the three countries reveal the surprising fact that the wavy hair found since Gandhara times was never used in Korean or in Japanese works, though it is found in Chinese cave sculpture. The spiral curls in Japanese sculpture of the Asuka period are not to be seen in the Pinyang or Kuyang caves or in any of the Lungmen-style stone Buddhas. These curls are not unknown, however, in Chinese gilt-bronze statues of this style. Japanese statues of the Asuka period and Korean statues of a comparable period all have spiral curls. In Japanese statues of the later Hakuho period the curls are sometimes used and sometimes omitted.

Mudras (symbolic gestures) in Chinese Buddhist statues for these periods seem to have differed from those found in Korea and Japan. The stone Buddha (Fig. 177) in the Pinyang cave extends only the index finger of his left hand, the other fingers are curled inward and up. As I said earlier on, in the discussion of the Horyu-ji Shaka Triad, however, representations of Shaka usually manifest the *yogan* (wish-granting) mudra, in which both the index and middle fingers are extended. Some Northern Wei statues use the same mudra, which was frequent in the late sixth century in the Korean kingdoms of Koguryo and Silla. Obviously, this is the source of the convention in Japanese art.

The arrangement and shape of the draperies flowing forward over the front of the pedestal supplies hints about the transmission of styles from China through Korea to Japan. This cascade of folds reaches its largest size in the Horyu-ji Shaka

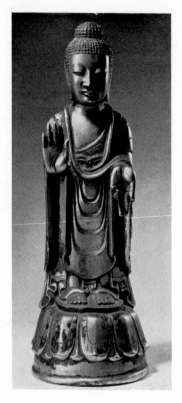
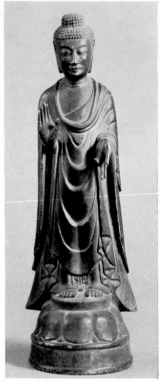

181 (far left). Buddha (first half of seventh century). Bronze; overall height, 34.5 cm. Tokyo National Museum.

182 (left). Buddha (first half of seventh century). Bronze; overall height, 33.9 cm. Tokyo National Museum.

Triad (Fig. 27). The draperies of the statue in the Pinyang cave are smallest, and those in the Kuyang cave fall somewhere between the two extremes. In pure Lungmen-style statues, the mass of folds is divided into a section falling from the right foot and another section falling from the left foot. This is not the case in Asuka-period Japanese statues, in which the cascade forms a single, well-ordered curtain of folds. The folds themselves assume three shapes. In the Lungmen statues, the ends of the folds are pointed; this is probably the oldest version. In a later version, the ends of the draperies are rounded. In still another style, the draperies are a single curtainlike sheet. The Asuka style derives from the Lungmen version, though the bottoms of the folds are rounded and the entire arrangement is treated in an ornamental fashion. Though the Asuka style follows the Chinese tradi-

tion, its prototype is a style somewhat later than the earliest Lungmen. The style probably entered Korea in the early sixth century, developed there for about fifty years until the end of the century, and then passed into Japan.

In general, the mandorla (Fig. 30) behind the Horyu-ji Shaka Triad can be placed in the Lungmen style, although the presence of a ring of hemispherical jewels inside the ring of scrolls, and the ring of radial lines within the concentric-circle part of the composition set it apart from the statues of the Pinyang cave. The radial-line ring appears in the statues in some of the Wei caves that were begun in the period between 523 and 527 and occasionaly in works of dates later than the Eastern Wei period. The ring of hemispherical jewels was used widely in the Buddha niches in the Kuyang cave but disappeared later only to turn up in such

183. Triad (second half of seventh century). Bronze; height of center figure, 34.2 cm. Tokyo National Museum.

isolated cases as the Eastern Wei gilt-bronze Buddha of 536 (Fig. 180).

In terms of artistic excellence, the Horyu-ji Shaka Triad in no way falls short of the standards set by certain of the images of the Pinyang and Kuyang caves. If the Asuka-period statue were larger it would rival its Chinese forerunners in terms of grandeur and majesty, as well.

The wooden statue of Yakushi at Horin-ji temple (Fig. 60) is in the same general form as the Horyu-ji Shaka group, though technically it is further advanced, as can be seen in the face and robes. For example, the folds of the forward-flowing draperies are treated in a lucid, systematic fashion, indicating that the statue is based on the styles of either the late Lungmen or the Northern Ch'i or Northern Chou dynasties.

No large standing Buddha figures have survived in Japan, but there are a number of small ones among the treasures donated by the Horyu-ji to the Imperial Household. These statues can be divided into two major categories: those belonging to the Lungmen sculptural tradition (Figs. 181, 182) and a later group with round faces and more or less straight-hanging robes. The first group of Japanese figures dates from the Asuka period, and the second from the Hakuho period. The round, childlike faces and realistically treated robes of the second group of statues place them in the style tradition of the Northern Ch'i and Northern Chou dynasties. Assigning definite years to these statues is extremely difficult. About all that can be said on the subject, as far as the works shown in this book are concerned, is that the statue in Figure 181 is probably older than the one in Figure 182 and that both were made in the late Asuka period. The triad in Figure

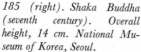

184 (left). Buddha (second half of seventh century). Bronze; overall height, 36.3 cm. Tokyo National Museum.

185 (right). Shaka Buddha (seventh century). Overall height, 14 cm. National Museum of Korea, Seoul.

186 (far right). Bodhisattva (Eastern Wei; first half of sixth century). Cave 2, T'ienlung-shan, Shansi Province, China.

183 and similar triads probably date from the Hakuho period. The round face and slightly flared costume of the small golden Buddha figure (Fig. 185) found in the pagoda of the Hwangbok-sa temple in Korea and now owned by the National Museum of Korea suggest that the statue was made in the seventh century, when Lungmen sculpture was popular.

YUMEDONO KANNON. The style of the Yumedono Kannon (Fig. 51) derives from that of late Lungmen works. The closest Chinese counterpart to the Horyu-ji work is the Bodhisattva figure (Fig. 186) in the second cave at T'ienlung-shan. These caves are usually assigned to the Eastern Wei period (534–50). The stylistic similarities between the two works are numerous. Both figures are tall and slender. The robes are arranged in a similar manner, and the lower draperies flare in symmetrical

side projections resembling fish fins. In both cases, the neck ornaments are solid plates and the two loops of the scarflike garment (ten'i) hanging from both shoulders cross with each other in front of the knees. Gilt-bronze and terra-cotta figures, uncovered near Pyongyang and probably produced in the ancient Korean kingdom of Koguryo (Figs. 187, 188), have similar traits.

The Lungmen style of representing Bodhisattvas —which was employed in China in the early sixth century, in Korea in the late sixth century, and in Japan about the beginning of the seventh century— can be seen in other Japanese works of this period, including the attendant statues of the Shaka Triad in the Horyu-ji Golden Hall (Fig. 23), the so-called Shingai Kannon (Fig. 63), and the Kannon Bodhisattva of Figure 57.

This general trend makes the stylistic derivation

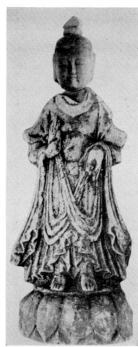

187 (far left). Bodhisattva (probably Koguryo; second half of sixth century). Bronze; overall height, 15.1 cm. Toksu Palace Museum of Fine Arts, Seoul.

188 (left). Bodhisattva (Koguryo; sixth to seventh century). Terra cotta; overall height, 17.5 cm.

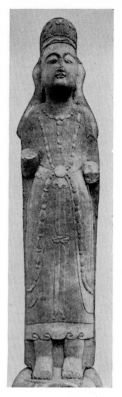

189 (right). Bodhisattva (Northern Ch'i; 576). Sandstone; overall height, 147.3 cm.

of the Yumedono Kannon seem simple, when in fact there are a number of complications. For example, in addition to the crossed-over loops in front of the knees, the statue has an additional drapery tied in a bow. A similar bow is to be seen in the Bodhisattva in Figure 57, and in the so-called Kudara Kannon. The use of a bow together with crossed draperies and bead jewels is found at its earliest in such works of the Northern Ch'i period as the statue dated 576 (Fig. 189), while in the Sui period their use was frequent. Consequently, in analyzing the developments that produced the Horyu-ji Yumedono Kannon, it is necessary to take these Ch'i and Sui styles into consideration.

The Bodhisattva figure with symmetrically flaring finlike projections from the right and left sides of the draperies seems to have been a popular Chinese device until the Sui period. It is found in both bronze statues and terra-cotta panels. A bronze Bodhisattva now owned by the Tokyo University of Arts (Fig. 190) is heavily encrusted with hanging jewels, but if it were possible to remove them, the strong resemblance to the Yumedono Kannon—even to the crown—would become immediately apparent.

In some points, the Yumedono Kannon is quite different from its Chinese models. Though the form occurs in Korea, in no Chinese statues of Bodhisattvas do the hands hold a jewel in front of the chest. In the bottom of the skirt of the Yumedono Kannon occurs an odd wavelike pattern that is not found in Lungmen styles and that seems to have been a touch added by a Japanese sculptor. Whereas the shapes of the eyes are exactly like those of the Shaka Triad, their entirely different expression suggests that by the time the Yumedono statue was

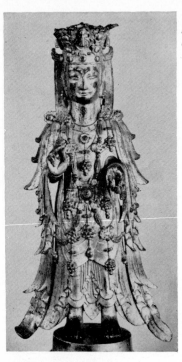

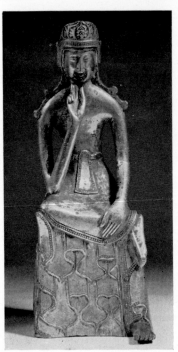

190. Bodhisattva (Sui; c. 600). Bronze; height of figure, 46 cm. Tokyo University of Arts.

191. Miroku Bodhisattva (second half of sixth century). Bronze; overall height, 28.7 cm. Tokyo National Museum.

made the style had taken root in Japan and had therefore lost its original austere rigidity.

In spite of these somewhat unusual characteristics in the statue itself, the mandorla is a masterpiece of Lungmen refinement and beauty. The combined vine-and-blossom scrolls of the major ring are often found in Lungmen mandorlas, as is the fluid form of the outer ring of flames.

In conclusion, I can say that though the Yume-dono Kannon is largely Lungmen in style, it includes a number of characteristic touches that suggest a rooting of the style in Japanese soil. A masterwork of Asuka-period sculpture, the statue is by no means inferior in any respect to its Chinese counterpart, the Bodhisattva figure in the second cave at T'ienlung-shan.

FOUR CELESTIAL KINGS. Because of the distinctive stylistic characteristics of the statues of the Four Celestial Kings in the Horyu-ji Golden Hall it is difficult to locate counterparts in either Korea or

China. It is not unusual to find Chinese examples of the Kongo Rikishi type guardian statues, and sometimes niches in Lungmen caves house guardian figures wearing armor; but these are never clearly identified as the Four Celestial Kings. Although a figure in the large central cave at Northern Hsiang-t'ang-shan is clearly a guardian of some kind, it is not identified as one of the four kings. Nonetheless, its width, straight posture, and absolute lack of movement suggest a resemblance with the Horyu-ji figures. This representative work of Northern Ch'i cave sculpture was probably made around 560, which means that there is a gap of about one century between it and the Horyu-ji statues. This is the only example of Buddhist sculpture in China that bears any resemblance to the Horyu-ji kings, although funerary statues of warriors of the Northern Wei and Sui periods are bulky and rigidly straight too. Furthermore, these funerary figures are dressed in armor over smooth cloth garments,

the pleats of which are arranged in systematic ornamental patterns. Of course, the funerary figures and the Horyu-ji kings do not agree in all details. For instance, the styles of armor are different. But they are similar enough to suggest stylistic relationship.

The halberds of the four kings in the Horyu-ji are wound with bronze wire and ornamented with bronze filigree. Halberds like these sometimes occur in ancient Korean burial mounds; perhaps the most noted example of the style is the halberd made of gold that was found at the Golden Crown Tomb at Kyongju, Korea. Chinese documents, however, mention the actual battle use of halberds bound with silver wire; consequently, this weapon style may be originally Chinese.

Although the historical forerunners of the Horyu-ji kings can no longer be traced with certainty, the statues are nonetheless masterpieces that recall the works in the caves at Northern Hsiangt'ang-shan.

MEDITATING BODHISATTVAS. As I have already said, the statue in the Chugu-ji represents the Buddha of the Future, the Bodhisattva Miroku. Statues of meditating princes are very old, and it is uncertain when they became associated with the worship of Miroku. It would seem that the association was already fairly well established by the Eastern and Western Wei, Northern Ch'i, and Northern Chou periods, since at those times white-jade statues of Miroku in this posture enjoyed a certain vogue. The idea probably passed through the three Korean kingdoms, ultimately to reach Japan. Although there is no documentary proof, in Korea these statues seem to have been worshiped as Miroku.

Including the small figures in gilt bronze, there are many statues of Miroku in the meditating posture. Among the treasures presented by the Horyu-ji to the Imperial Household are the bronze figure seen in Figure 191 and the one dating from the year *heiin* (Fig. 61; see page 80). Both have slender, immature bodies characteristic of Korean sculpture. Pinpointing the style as Korean of the late sixth century will lend confirmation to the date 606 for the second statue.

Although the characteristics of these statues are

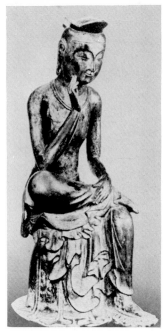

192. *Miroku Bodhisattva (c. 600). Bronze; overall height, 90 cm. Toksu Palace Museum of Fine Arts, Seoul.*

Korean and were eventually transmitted as such to Japan, similar traits are not found in Chinese works. There is, however, an older version of this style, examples of which remain from the Eastern and Western Wei. These Chinese figures, in what may be called the Lungmen style, are in the meditating posture with the left leg raised and the left hand brought to the cheek.

One step more advanced in style and technique is the type represented by the Crowned Miroku (Figs. 78, 171) at the Koryu-ji, Kyoto, and the bronze statue owned by the Toksu Palace Museum in Seoul (Fig. 192). The Japanese statue is thought to have been brought from Korea, and indeed the two resemble each other to the smallest details. The bodies are full-fleshed, the hands are pliant in appearance, and the expressions are elegant and lovely. Generally speaking both belong to the style traditions of the Northern Ch'i and Northern Chou periods.

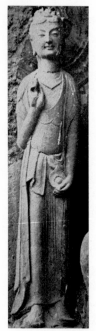
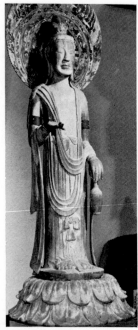

193 (left). Right-hand attendant of triad (Eastern Wei; first half of sixth century). Clay. Maichi-shan, China.

194 (right). Kannon Bodhisattva (second half of seventh century). Wood; height of figure, 179.5 cm. Horin-ji, Nara. (See also Figure 85.)

The famous Miroku of the Chugu-ji (Fig. 59) belongs in this same general group. It has similar scroll-shaped curls that descend in symmetrical lines along the outer edges of the shoulders. The costume is limited to bold draperies falling to the front below the waist. The body has a softly fleshed quality and the fingers a pliant appearance. In these last two characteristics, the Chugu-ji statue is especially close to the Miroku in the Toksu Palace Museum.

The double chignon on the head of the Chugu-ji Miroku links it in style to the Miroku uncovered at excavations at Nachi, Wakayama Prefecture (Fig. 65). In China the double chignon was traditionally reserved for representations of children. In Japan it may have been thought a feminine trait; at any rate, there is a famous figure of Maya, the mother of Shaka, in which this august lady wears her hair in a double chignon. The Miroku of the Chugu-ji has a gentle, feminine beauty.

The Miroku of the Yachu-ji (Fig. 62), a masterpiece of Hakuho sculpture of the type, belongs in the Ch'i and Chou traditions. The naked upper part of the body and the richly ornate draperies of the lower body are balanced and contained within a stable cone form.

Many Miroku statues in the meditating pose were produced in Korea, too. The incomplete stone statues shown in Figures 172 and 173 are two cases in point. In addition to these, a large number of white-jade figures have been found in Korea. Most of these, however, are small devotional figures much smaller than the Chugu-ji and Koryu-ji statues. Nonetheless lovely and appealing, they give one the sense that people of times long ago must have used them with deep faith and trust in the miracles to be worked by the Bodhisattva Miroku, the Buddha of the Future.

In China, immediately prior to the popularity of faith in the Buddha Amida, statues like these in the meditating position were in fashion. Belief in Miroku seems to have gained a large number of adherents in Japan, too, immediately preceding the development of faith in Amida and Yakushi. This may have been roughly at the time of the famous Taika Reforms, promulgated in 646.

OTHER BODHISATTVAS. The Kudara Kannon (Figs. 55, 82) is so distinctively tall and slender that a close counterpart is impossible to locate. Some aspects of the figure, however, do belong to the Lungmen tradition: the movement of the garment, the dignity and grandeur with which the garment is worn, and the very slenderness of the form. In the Eastern Wei caves at Maichi-shan, introduced to the world after World War II, there is a slender attendant statue (Fig. 193) that seems to bear a relationship to the style of the Kudara Kannon. It would certainly be wrong to deny this relationship, for it is all too apparent. But I do not find it necessary to specify this particular statue to relate the Kudara Kannon to the art of the Northern Wei and Ch'i and Chou dynasties.

During those periods, the central statues in triads were usually composed within the wide, low bounds of an equilateral triangle, but the attendant figures were almost invariably tall, slender, and almost flamelike in form. This characteristic arrangement of the three components of the triad seems to embody the spirit of Lungmen sculpture.

The Horin-ji Kannon, shown in Figure 194, is not as slender as the Kudara Kannon, but the hands are held in the same position. There is a phial in the left hand. The upper body, however, is naked, and the draperies of the costume are symmetrically arranged, as they are in the attendant figures in the Amida Triad in Lady Tachibana's Shrine.

In contrast to the Kudara Kannon and the Horin-ji Kannon, which clearly belong to the older Lungmen tradition, the Six Bodhisattvas (Figs. 58, 88, 89) have three-section coronets, high-piled coiffures, and abundant jewelry, which put them more in the later styles of the Northern Ch'i and Chou dynasties.

The Yumetagai Kannon (Figs. 124, 136) has a three-plate coronet but the still more elaborately heaped coiffure brings it closer in style to the art of T'ang-period China. Although the Kannon of the Kakurin-ji (Fig. 123) comes a step closer to T'ang art, it nonetheless retains certain Hakuho traces in the immaturity of the workmanship and the childlike qualities of the face.

A group of statues including the Kannons of the Ichijo-ji (Fig. 125) and the Gakuen-ji (Fig. 122) have already been so thoroughly naturalized in Japan that it is almost impossible to find statues that correspond to them in Chinese or Korean art. The fact that they were made in the outlying districts and not in the cultural center of the Japan of their time removes them still further from continental art styles. Nevertheless, the overabundance of jewels and ornaments hints at a connection with Ch'i, Chou, and Sui styles.

The Kannon of the Kanshin-ji in Osaka (Fig. 64), too, is richly bedecked with symmetrically placed jewels, like statues of the Sui period, though it is tall and slender and holds a jewel in its hands like the Yumedono Kannon.

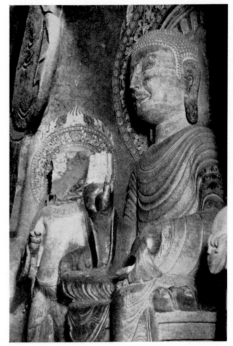

195. Buddha (Northern Ch'i; second half of sixth century). Stone. North Caves, Northern Hsiangt'ang-shan, China.

AMIDA TRIAD IN LADY TACHIBANA'S SHRINE. Belief in Amida Buddha is reflected in Japanese arts and crafts as early as the Tenjukoku embroidery (Fig. 49), but it was not fully established until the seventh century. It was popular in China, however, from the sixth century; and the art styles that are the source of the Amida Triad in Lady Tachibana's Shrine (Fig. 137) were popular in the Ch'i, Chou, and Sui periods (mid-sixth to early seventh century). The Amida statue itself is a classic example of Japanese Hakuho-period art, with its full body covered with thin garments and its stately posture. Although the meditating Buddha statue in the Northern Hsiangt'ang-shan caves (Fig. 195) is not in the same posture, the full-fleshed body, the somewhat rigid and flattish face, the thin

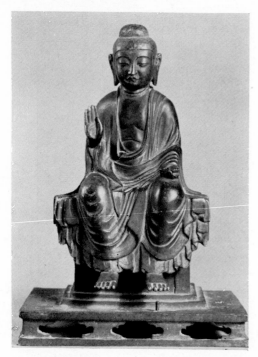

196. Buddha (second half of seventh century). Bronze; overall height, 28.7 cm. Tokyo National Museum.

material of the garments, and the small number of folds resulting from this thinness correspond nicely to similar traits in the Amida in the Japanese shrine. It is impossible to single out any one statue that is a definite forerunner of the figure in Lady Tachibana's Shrine, but it can be said that, while the idea is Japanese and Hakuho period, the styles are largely Ch'i, Chou, and Sui Chinese.

THE SO-CALLED Ko Yakushi (Fig. 119) at the Shin Yakushi-ji in Nara has a mouth resembling that of the Yumetagai Kannon. The styles of the Ch'i, Chou, and Sui periods in China are noticeable in this statue—especially in the drapery of the costume —and in the seated Buddha at the Jindai-ji (Fig. 120). The characteristic features of these works are not to be seen in art of the T'ang period.

The seated statue of Miroku in the Horyu-ji Pagoda (Fig. 143) and a seated Buddha (Fig. 196) in the collection given to the Imperial Household

by the Horyu-ji are both one step more advanced than the Jindai-ji figure, as regards both facial expression and draperies. They reflect the style of the T'ang period at its peak. But perhaps more important, with all of their T'ang realism and elegance, these works are fundamentally Japanese. It is true that the styles seem less naturalized than those that were popular in the Asuka and Hakuho periods in Japanese art history, but Japanese art of the Tempyo period—the art represented by the clay statues in the Pagoda—while close to its T'ang models, is excellent in its own right. This sculpture and other contemporaneous work are not mere copying. Japanese art at this time had already reached a level of brilliance independent of the models it was based on. The excellence of this level is more than adequately shown in the two realistic dry-lacquer statues of the monks Gyoshin (Fig. 142) and Dosen (Fig. 156) in the Yumedono of the Horyu-ji.